T0123514

An Analysis of

# Robert O. Keohane's

## After Hegemony

Ramon Pacheco Pardo

LONDON AND NEW YORK

Published by Macat International Ltd
24:13 Coda Centre, 189 Munster Road, London SW6 6AW.

Distributed exclusively by Routledge
4 Park Square, Milton Park, Abingdon, Oxon OX14 4RN
605 Third Avenue, New York, NY 10017

*Routledge is an imprint of the Taylor & Francis Group, an informa business*

www.macat.com
info@macat.com

*Cataloguing in Publication Data*
A catalogue record for this book is available from the British Library.
Library of Congress Cataloguing-in-Publication Data is available upon request.
Cover illustration: Etienne Gilfillan

ISBN 978-1-912303-32-8 (hardback)
ISBN 978-1-912127-38-2 (paperback)
ISBN 978-1-912282-20-3 (e-book

**Notice**

# CONTENTS

# THE MACAT LIBRARY

The Macat Library is a series of unique academic explorations of seminal works in the humanities and social sciences – books and papers that have had a significant and widely recognised impact on their disciplines. It has been created to serve as much more than just a summary of what lies between the covers of a great book. It illuminates and explores the influences on, ideas of, and impact of that book. Our goal is to offer a learning resource that encourages critical thinking and fosters a better, deeper understanding of important ideas.

Each publication is divided into three Sections: Influences, Ideas, and Impact. Each Section has four Modules. These explore every important facet of the work, and the responses to it.

This Section-Module structure makes a Macat Library book easy to use, but it has another important feature. Because each Macat book is written to the same format, it is possible (and encouraged!) to cross-reference multiple Macat books along the same lines of inquiry or research. This allows the reader to open up interesting interdisciplinary pathways.

To further aid your reading, lists of glossary terms and people mentioned are included at the end of this book (these are indicated by an asterisk [*] throughout) – as well as a list of works cited.

Macat has worked with the University of Cambridge to identify the elements of critical thinking and understand the ways in which six different skills combine to enable effective thinking.
Three allow us to fully understand a problem; three more give us the tools to solve it. Together, these six skills make up the **PACIER** model of critical thinking. They are:

**ANALYSIS** – understanding how an argument is built
**EVALUATION** – exploring the strengths and weaknesses of an argument
**INTERPRETATION** – understanding issues of meaning

**CREATIVE THINKING** – coming up with new ideas and fresh connections
**PROBLEM-SOLVING** – producing strong solutions
**REASONING** – creating strong arguments

To find out more, visit **WWW.MACAT.COM.**

# CRITICAL THINKING AND *AFTER HEGEMONY*

## Primary critical thinking skill: CREATIVE THINKING
## Secondary critical thinking skill: REASONING

Robert O. Keohane's *After Hegemony* is both a classic of international relations scholarship and an example of how creative thinking can help shed new light on the world.

Since the end of World War II, the global political landscape had been dominated by two superpowers, the USA and the USSR, and the tense stand-off of the Cold War. But, as the Cold War began to thaw, it became clear that a new global model might emerge. The commonly held belief amongst those studying international relations was that it was impossible for nations to work together without the influence of a hegemon (a dominant international power) to act as both referee and ultimate decision-maker. This paradigm – neorealism – worked on the basis that every nation will do all it can to maximize its power, with such processes only checked by a balance of competing powers.

Keohane, however, examined the evidence afresh and came up with novel explanations for what was likely to come next. He went outside the dominant paradigm, and argued for what came to be known as the neoliberal conception of international politics.

## ABOUT THE AUTHOR OF THE ORIGINAL WORK

Born in 1941 in the US city of Chicago, **Robert O. Keohane** is regarded as one of the most influential thinkers and teachers in the world of international relations. He is a fellow of both the American Academy of Arts and Sciences and the American Academy of Political and Social Science. His 1984 book *After Hegemony* saw him awarded the prestigious Grawemeyer Award for Ideas Improving World Order. He has edited the magazine *International Organization*, and has also been president of the International Studies Association and the American Political Science Association.

## ABOUT THE AUTHOR OF THE ANALYSIS

**Dr. Ramon Pacheco Pardo** is Senior Lecturer in International Relations at King's College London. He holds a PhD in International Relations form the London School of Economics and is a research associate at the Lau China Institute and the Global Studies Institute in Hong Kong. Dr Pacheco Pardo has held visiting positions at the Lee Kuan Yew School of Public Policy and Korea University, and sits on the editorial board of *Global Studies Journal*.

## ABOUT MACAT

### GREAT WORKS FOR CRITICAL THINKING

Macat is focused on making the ideas of the world's great thinkers accessible and comprehensible to everybody, everywhere, in ways that promote the development of enhanced critical thinking skills.

It works with leading academics from the world's top universities to produce new analyses that focus on the ideas and the impact of the most influential works ever written across a wide variety of academic disciplines. Each of the works that sit at the heart of its growing library is an enduring example of great thinking. But by setting them in context – and looking at the influences that shaped their authors, as well as the responses they provoked – Macat encourages readers to look at these classics and game-changers with fresh eyes. Readers learn to think, engage and challenge their ideas, rather than simply accepting them.

# WAYS IN TO THE TEXT

## KEY POINTS

- Born in Chicago in 1941, Robert O. Keohane is one of the most important scholars of international relations*—the study of the relationships between nation states and organizations—of the late twentieth and early twenty-first centuries.

- In his 1984 book *After Hegemony*, Keohane first analyzes neorealism,* a school of thought based on the assumption that nations find themselves compelled to act in their own self-interest according to the prevailing structures of power. He then presents a neoliberal* theory of international relations, according to which international relations can be conducted on cooperative principles without the influence of a dominant international power.

- The neorealist*–neoliberal debate was the most important in the field of international relations throughout the 1980s and 1990s. *After Hegemony* offered a key contribution to the debate.

### Who Is Robert O. Keohane?

Robert O. Keohane is one of the most important and influential international relations scholars of the late twentieth and early twenty-first centuries. He was born in the American city of Chicago in 1941

to politically active parents, and developed an interest in politics from a young age. He studied politics at Shimer College, affiliated to the University of Chicago, before moving on to graduate work at Harvard University where he obtained his PhD in 1966. He has since held a number of teaching positions and has written widely on international relations. His book *After Hegemony: Cooperation and Discord in the World Political Economy* is a central work in the field, having laid out a theory of international relations—neoliberalism*—that has been widely used since its publication.

Keohane later honed his theory further in works such as "Two Cheers for Multilateralism,"*[1] co-authored with his frequent collaborator Joseph S. Nye, Jr.* and "International Institutions: Two Approaches,"[2] among others.

Building on the theory developed in *After Hegemony*, Keohane's work can perhaps be divided into two strands.

He has written on the evolution and functioning of different international regimes* (roughly, sets of principles, norms and decision-making procedures agreed by a number of nations) in articles such as "The Regime Complex for Climate Change," co-authored with David G.Victor[3] and "Punctuated Equilibrium in the Energy Regime Complex," which he co-authored with Jeff Colgan and Thijs Van de Graaf.[4] More recently, Keohane has turned his attention to questions about the status of American hegemony* (that is, dominance) and to the role of the United States as a leader in global affairs. His paper "Hegemony and After: What Can Be Said about the Future of American Leadership?" is a good example of his research in this area.[5]

Currently, Keohane is professor of international affairs at the Woodrow Wilson School of Public and International Affairs at Princeton University in the United States. His long list of honors includes the Centennial Medal from the Harvard Graduate School of Arts and Sciences, the Susan Strange Award from the International Studies Association and several honorary doctorates.[6] He received the

Grawemeyer Award for Ideas Improving World Order in 1989.[7]

## What Does *After Hegemony* Say?

*After Hegemony* lays out a neoliberal theory of international relations. Neoliberalism is based on the idea that states can cooperate even without the influence and support of a single dominant power, known as a hegemon,* as long as they obtain absolute gains*—that is, cultural or economic benefits gained as the result of acting on a decision.

Cooperation usually takes place through the decision of states to join an international regime. Crucially, this means that cooperation is neither forced on a state, nor is cooperation the result of a hegemon— or dominant power—taking the lead in the creation and continuation of a regime. According to this theory, cooperation is a more potent factor in the relations between states than neorealist theory allows.

Keohane develops this line of thought in *After Hegemony*. First, he explains the flaws in the realist* theory of international relations, according to which international relations are based on competition, self-interest and aggressive pragmatism.* Keohane presents the evidence to support his argument that cooperation takes place even without the supporting influence of any single, dominantly powerful nation. Realist theory, he argues, cannot explain this.

Neoliberal theory, on the other hand, lets us understand how states come to cooperate. It is a theory that takes account of certain key points:

- Rational choice*—the idea that human behavior is driven by logical decisions designed to be beneficial
- Functionalism*—the theory that states have sufficient interests in common to arrive at similar decisions and further integration
- Bounded rationality*—the theory that rational behavior is limited by the amount of information we have, by how much information the mind is capable of processing, and by the time required to think something through.

International cooperation is founded on the development of international regimes—institutions governing law, trade agreements, military pacts, and the like. States have a rational expectation that others will respect a regime they have freely joined by rational choice. And the interests of the states making up that regime should then converge, according to functionalism.[8] Finally, bounded rationality will come in to play, affecting the expectations of that group of states.

Importantly, Keohane does not argue that states put the common good before their self-interest when they participate in an international regime. For those states, cooperation through an international regime is, indeed, their self-interest in action. This implies that the sovereignty* of a state is not reduced when it joins a regime—mutual suspicions have simply been overcome by shared interests.[9] International regimes, therefore, do not change the nature of international relations. Without any central authority to impose any kind of law, they remain in a state of anarchy,* with no authority compelling them one way or another. A regime simply alters the expectations of self-interested states, making cooperation between them possible. Having explained this, Keohane goes on to apply his neoliberal theory of international relations.

The decline of American hegemony, he says, has not stopped cooperation—a position he supports by comparing case studies of regimes of trade and money on one hand, and the consumers' oil regime on the other.[10]

According to Keohane, the trade and monetary regimes survived the decline of the United States in the 1970s for two reasons. First, these regimes were institutionalized; in other words, there were institutions underpinning both regimes. Second, the members of these two regimes wanted them to survive because of the benefits they gained from them. In contrast, the consumers' oil regime failed during the oil crises* of the 1970s because there was no mechanism for their members to cooperate. Following on from Keohane, the success of the trade and monetary regimes—and the sharp contrast with the failure

of the consumers' oil regime—proves that regime participants can choose to cooperate freely. This is the case, even if their core interests are at stake.

## Why Does *After Hegemony* Matter?

Throughout the 1980s, there was a debate in the field of international relations between neorealist and neoliberal scholars with competing views about the nature of relations among states. Following the publication of the political theorist Kenneth Waltz's* *Theory of International Politics* in 1979, neorealism emerged as the dominant theoretical model. Waltz developed a clear and well-structured neorealist theory of international relations grounded in scientific methods of gathering and analyzing data that lent it an unmatched authority.[11]

When Keohane published *After Hegemony* in 1984, he was looking to offer a new, neoliberal approach to the study of international relations as a direct challenge to Waltz's theory. As such, since its publication *After Hegemony* has become the starting point for neoliberal thought. Students and scholars of international relations alike have to read the work in order to understand one of the core debates of international relations: the debate between neorealist and neoliberal thought.

Keohane's theory continues to be one of the most relevant theoretical approaches to explain how states interact with each other and why they act the way they do.[12] Considering the number of works either founded on, or opposed to, the arguments presented in the book, it is necessary to engage with it even if you wish to disagree with Keohane's analysis.

Furthermore, *After Hegemony* offers an excellent example of how to formulate a theoretical model that can be used to explain actual events. At the outset of *After Hegemony*, for example, Keohane looks at the existing theoretical model he is looking to dismantle, carefully dealing with its theoretical core rather than making a caricature of it.

He then builds his own theory, making sure that it is grounded in

pre-existing ideas, while presenting its own interpretation. This ensures that, although Keohane's new theory is entirely original, its roots are nonetheless in the existing literature. Finally, *After Hegemony* tests the theory presented through detailed case studies—on international institutions like trade and monetary regimes and the 1970s oil crises—and so brings together both theory and data. The book is useful, then, for those who want to see how and why social science helps us to understand human and social behavior.

## NOTES

1   Robert O. Keohane and Joseph S. Nye, Jr., "Two Cheers for Multilateralism," *Foreign Policy* 60, no. 1 (1985): 148–67.

2   Robert O. Keohane, "International Institutions: Two Approaches," *International Studies Quarterly* 32, no. 4 (1988): 379–96.

3   Robert O. Keohane and David G. Victor, "The Regime Complex for Climate Change," *Perspectives on Politics* 9, no. 1 (2011), 7–24.

4   Jeff Colgan, Robert O. Keohane and Thijs Van de Graaf, "Punctuated Equilibrium in the Energy Regime Complex," *The Review of International Organizations* 7, no. 2 (2012): 117–43.

5   Robert O. Keohane, "Hegemony and After: What Can Be Said about the Future of American Leadership?" *Foreign Affairs* 1, no. 4 (2012): 1–5.

6   "Curriculum Vitae," Princeton University, accessed January 4, 2015, http://www.princeton.edu/~rkeohane/cv.pdf.

7   "Curriculum Vitae," Princeton University.

8   Robert O. Keohane, *After Hegemony: Cooperation and Discord in the World Political Economy* (Princeton: Princeton University Press, 1984), 83–4.

9   Keohane, *After Hegemony*, 49–64.

10  Keohane, *After Hegemony*, 135–240.

11  See Kenneth Waltz, *Theory of International Politics* (New York: McGraw Hill, 1979).

12  Daniel Maliniak et al., *TRIP Around the World: Teaching, Research, and Policy Views of International Relations Faculty in 20 Countries* (Williamsburg, VA: Teaching, Research, and International Policy (TRIP) Project, 2012), 27.

# SECTION 1
## INFLUENCES

# MODULE 1
# THE AUTHOR AND THE
# HISTORICAL CONTEXT

## KEY POINTS

- Published in 1984, *After Hegemony* is one of the most important texts in the field of international relations* and is central to understanding neoliberal* thought—founded on the assumption that, among other things, cooperation between nations is possible even without the influence of a dominant power standing to benefit the most.

- Keohane was born into a family of social scientists with an interest in politics, and this affected his education and career choices.

- The political environment of the United States in the 1980s and Keohane's previous written work with Joseph S. Nye, Jr.* influenced *After Hegemony*.

### Why Read This Text?

Robert O. Keohane's *After Hegemony: Cooperation and Discord in the World Political Economy* is one of the classic texts of neoliberalism* in international relations. Keohane was not the first person to use the term "neoliberalism," because the theory first emerged back in the 1930s.[1] Nevertheless, he did play a key role in updating the concept and applying it to the field of international relations. The text is original because of how Keohane presents neoliberalism's key principles, as well as how he presents a methodical analysis of the international system. Keohane was inspired by a number of international relations scholars, among them the political scientists

> ❝ There is no doubt that [Keohane] has been a pivotal figure in inspiring a whole generation of graduate students to examine 'regimes' in a vast array of issue-areas in international relations. He has provided a theoretical framework and a set of hypotheses that others have used to expand the empirical scope of international relations theory in the subfield of international political economy, which is now thriving in the discipline as a whole. ❞
> Martin Griffiths, *Fifty Key Thinkers in International Relations*

Stanley Hoffmann,* Joseph S. Nye, Jr., and Kenneth Waltz.*

*After Hegemony* is an indispensable guide to the study of international relations generally, and remains the most important neoliberal work in the field, laying out the theory's key principles perfectly clearly. These are:

- International institutions and structures can operate in the absence of a hegemon* (a dominant state) enforcing an agenda.
- International regimes* (sets of principles, norms and decision-making procedures agreed by a number of states) foster cooperation.
- Cooperation is not as uncommon as those who take the neorealist* position—a school of thought that assumes international relations to be founded on principles of self-interest and pragmatism)*—would suggest.

The book was an overwhelming success. *After Hegemony* remains one of the most popular works in the field of international relations, with over 8,000 academic citations at the time of writing.[2] As a school

of thought, neoliberalism is one of the most popular theoretical approaches to the study of international relations,[3] and for this reason, Keohane has been considered to be among the most influential scholars of international relations for the past 20 years.[4]

## Author's Life

Robert O. Keohane was born in the city of Chicago in the American state of Illinois, in 1941, to politically left-leaning parents. Both were social scientists, his father a teacher at Chicago and Shimer colleges and his mother a high school teacher. Keohane's parents were also involved in local politics through the Democratic Party. His university education and early career were influenced by his parents' political activism. His work reflects traditional liberal ideas, particularly those connected to the benefits of cooperation and openness in the world economy.

Keohane entered Shimer College, affiliated to the University of Chicago, at the age of 16 to study politics, and went on to do graduate work at Harvard University.[5] After completing his PhD on the politics of the United Nations General Assembly,*[6] he became an academic. During a distinguished career, Keohane has worked at Swarthmore College, Stanford University, Brandeis University, Harvard University, and Duke University. Currently, he is professor of international affairs at the Woodrow Wilson School of Public and International Affairs, Princeton University.[7]

Keohane's ideological and educational background was reflected in *After Hegemony*—a book that helped to initiate neoliberalism as a school of thought in international relations.

## Author's Background

Keohane's first book was *Power and Interdependence: World Politics in Transition*, published in 1977 and co-authored with Joseph S. Nye, Jr. Many of the ideas developed in *After Hegemony* have their roots in this

work. Keohane finished *After Hegemony*, his first book as sole author, in January 1984, when he was a professor at Brandeis University, in Wellesley, Massachusetts. Keohane received a grant from the German Marshall Fund of the United States while researching and writing *After Hegemony*, and financial support from Stanford University and Brandeis University, the two institutions where he worked, while preparing the manuscript. He has been based on the east coast of the United States throughout most of his career, save for an eight-year stint living in California.

In some ways, when the book was first published in 1984, the United States was a less turbulent place, both politically and socially speaking, than it had been in the 1960s. The Vietnam War* was over and the United States and China had normalized diplomatic relations. American economic hegemony* (dominance) was being challenged by other states, however, notably Japan and Germany, and the right-wing administration of President Ronald Reagan* had ended its attempts to ease hostilities with another major world power, the Soviet Union* and had started a political strategy aiming to minimize Soviet influence in international affairs. The impact of all these developments can be seen in Keohane's work.

## NOTES

1   Taylor C. Boas and Jordan Gans-Morse, "Neoliberalism: From New Liberal Philosophy to Anti-Liberal Slogan," *Studies in Comparative International Development* 44, no. 2 (2009): 137–161.

2   "Robert Keohane, *After Hegemony*," Google Scholar, accessed May 13, 2015, https://scholar.google.com/scholar?cites=560052273688874574&as_sdt=20005&sciodt=0,9&hl=en.

3   Daniel Maliniak et al., *TRIP Around the World: Teaching, Research, and Policy Views of International Relations Faculty in 20 Countries* (Williamsburg, VA: Teaching, Research, and International Policy (TRIP) Project, 2012), 27.

4   Maliniak, *TRIP Around the World*, 49.

5   "Conversations with History: Robert O. Keohane," University of California,

Berkeley, March 7, 2008, accessed May 26, 2013, http://www.youtube.com/watch?v=5foxGFXNl-s.

6   "Theory Talk #9: Robert Keohane," Theory Talks, May 29, 2008, accessed May 26, 2013, http://www.theory-talks.org/2008/05/theory-talk-9.html.

7   "Curriculum Vitae," Princeton University, accessed January 4, 2015, http://www.princeton.edu/~rkeohane/cv.pdf.

# ACADEMIC CONTEXT

## KEY POINTS

- *After Hegemony* was published in a context of declining American power and questions about whether international cooperation really was possible.

- Keohane's work was an important part of the debate between neorealism\* and neoliberalism\* in international relations.\*

- Classical idealist\* authors (who believe that international relations need not be founded on self-interest and pragmatism)\* and contemporary neorealist\* scholars (who believe that the behavior of states is largely dictated by the international structure) both influenced Keohane's work.

### The Work in its Context

Robert O. Keohane's *After Hegemony: Cooperation and Discord in the World Political Economy* was published at a time when American economic hegemony\* (that is, its unrivaled dominant position) over the Western bloc\*—the United States, Western Europe, and those nations with similar political and economic systems—was being eroded.

Even though nobody contested the leading position of the United States in military and political affairs, new economic powers—most notably Japan and Germany—were undermining its economic supremacy, which explains the reference to the phrase "world political economy" in the title.

The United States was not sure whether to continue to provide support to the Bretton Woods\* system—a system of international

> ❝ Keohane's intellectual path to answering the question at the back of his mind in the early 1960s has moved from a direct challenge to realism to an attempt to accommodate its emphasis on the importance of power and self-interest in explaining the conduct of states. His answer is that, yes, power and self-interest are important, but writers such as Waltz, Gilpin and other structural realists exaggerate the degree to which the international system is anarchical. It is not. ❞
>
> Martin Griffiths, *Fifty Key Thinkers in International Relations*

monetary management that had underpinned economic growth in the Western bloc since the end of World War II.* A debate took place on the question of whether economic cooperation among Western powers could continue without American hegemony—that is, American dominance—or not. Keohane's book, discussing whether economic cooperation at an international level could be maintained without the United States shouldering the burden of taking a leading role, contributed to this debate.

*After Hegemony* addresses two of the chief areas of interest in international relations following the collapse of the Bretton Woods monetary system in 1971 and the oil crises* of 1972 and 1979, when the price of oil increased in the wake of political events in the Middle East, leading to economic difficulties in the West. In this context, the first question of whether states might cooperate to create a stable economic environment without the influence of a hegemon* (the United States, in this case) was very important. Keohane established that this was, indeed, possible.

Second, many political scientists were preoccupied with the question of whether cooperation between self-interested states in

periods of economic crisis was possible. Again, Keohane showed that this was also possible. These were two important contributions to neoliberal* thought in the field of international relations. Although Keohane built on ideas that already played a part in discussions concerning international relations, he contributed to the development of these ideas even before *After Hegemony* was published.

## Overview of the Field

When *After Hegemony* was published in 1984, neoliberalism was becoming one of the most important theoretical approaches to international relations. Since the late 1970s, neorealist thinking had generally been accepted in international relations circles.

Neorealists* tended to focus on security matters. Yet over time, it became clear that the economy was, in fact, an important part of a state's security. Economic performance was a key factor in determining military strength and how powerful a country was seen to be. Neorealist thought also emphasized relative gains*—the idea that a decision can be considered a good one so long as it delivers a comparative advantage. A state's overall power, then, was dependent on its relative superiority over other states.

Neoliberalism's* focus on *absolute* gains*—the idea that a decision can be thought successful if it simply brings *some* benefit to a nation— challenged this argument.

While neoliberals like Keohane did not challenge the idea that the international system was anarchical*—meaning that there is no higher authority and that states are the core units of analysis in international relations—they differed significantly from neorealists on the question of whether international cooperation was a key feature of that international system.

There had been, then, an ongoing debate between neorealists and neoliberals. While both agreed on the nature of the international system and the main actors in it, they differed in terms of their

understanding about how these actors responded to the existing structure. Both were looking to shift a view that everyone could agree on towards a different theoretical model. *After Hegemony* is central to this so-called "neo-neo" debate, because it confirmed Keohane as one of the leading scholars of the neoliberal school of thought in international relations.

## Academic Influences

The key concept Keohane presents in *After Hegemony* is that cooperation among states *is* possible even without a dominant power acting in its own interest to sustain it. Keohane decided this through a combination of empirical—that is, practical and scientific—observation and theoretical concepts, building on the work of international relations scholars such as Philip Noel-Baker* and Alfred Zimmern.* Both believed in idealist* theory, suggesting that cooperation among states was both possible and desirable.

Keohane saw that economic cooperation among Western states had clearly survived the end of the American hegemony that had existed in the years of the Bretton Woods system. Neoliberal authors such as Ernst B. Haas,* Stephen D. Krasner,* John Ruggie* and Oran R. Young* had been working to develop these ideas when *After Hegemony* was published. But Keohane's book clearly and systematically organized their thoughts, while also expanding on their ideas in that process. This positioned *After Hegemony* as one of the classic texts of neoliberalism in international relations.

Keohane seemed to have had a specific audience in mind when writing his book, looking to engage both scholars of international relations, and social scientists working on issues related to inter-state cooperation. However, *After Hegemony* does not seem to have been significantly shaped by the expectations of this audience, other than the international relations terminology the book contains.

# MODULE 3
# THE PROBLEM

## KEY POINTS

- *After Hegemony* looks at whether states can cooperate when there is no single dominant power, or "hegemon"*— an important component of neoliberal* thought.

- Keohane was part of a group of neoliberal scholars who challenged the dominant neorealist* view in the 1980s.

- The debate between neoliberalism* and neorealism* continues today.

### Core Question

The core question Robert O. Keohane tries to answer in *After Hegemony: Cooperation and Discord in the World Political Economy* is whether or not cooperation among states is possible in the absence of a hegemon (a single, dominant power) to sustain that cooperation. His argument is that it is. A closely related question, then, is *how*, precisely, cooperation might take place in those circumstances.

Cooperation at the international level is difficult to achieve because of the problems created by states' self-interest, the pursuit of relative gains,*—and the existence of free riders*—that is, states who benefit from international cooperation, but who do not contribute to it. Scholars who think that cooperation is only possible if there is a hegemon maintain that it—the dominant state—has the most to gain from international cooperation, which is why it is willing to support it in spite of these problems.[1] With *After Hegemony*, Keohane makes the case that this is not necessarily true, and that there are other reasons why states might cooperate even without the persuasive influence of a

> ❝ A state worries about a division of possible gains that may favor others more than itself. That is the first way in which the structure of international politics limits the cooperation of states. A state also worries lest it become dependent on others through cooperative endeavors and exchanges of goods and services. That is the second way in which the structure of international politics limits the cooperation of states. ❞
>
> Kenneth Waltz, *Theory of International Politics*

dominant state. Chief among them is the existence of international regimes* that foster cooperation.

### The Participants

*After Hegemony* was published as a contribution to the debate between supporters of neorealism and supporters of neoliberalism as to the most useful theoretical approach to the study of international relations.*

Keohane was already one of the most prominent neoliberal scholars thanks to *Power and Interdependence*, a book he co-wrote with the political theorist Joseph S. Nye, Jr.* in 1977. He wrote *After Hegemony* in order to lay out the main doctrines of neoliberal theory. In this Keohane was successful. The book became a classic neoliberal text and made Keohane the most popular neoliberal author in the field of international relations.[2]

Given the context of the debate to which it was responding, Keohane's book did not emerge in a vacuum. Most notably, it dealt in detail with the political theorist Kenneth Waltz's* *Theory of International Politics*, considered the founding neorealist text. In his 1979 book, Waltz argued that the structure of the international system was defined by a lack of leadership and governing authority—anarchy,* in other

words.[3] Since this structure was anarchical, cooperation among states was difficult to achieve, especially in the absence of a hegemon providing stability to the international system and bearing some of the costs associated with cooperation.[4]

Rejecting neorealism's views on the ways in which anarchy affects state behavior, especially cooperation, Keohane used *After Hegemony* to go against a central element of neorealist thought. But Keohane's book also shows the influence of other authors working on neoliberalism and international regimes.

The concept of the "international regime" as an institution of obligations and laws had been introduced to the field of international relations by the scholar John Ruggie.*[5] And Keohane accepted the political theorist Stephen D. Krasner's* definition of international regimes as "sets of implicit or explicit principles, norms, rules, and decision-making procedures around which actors' expectations converge in a given area of international relations."[6] Interdependence among states, a concept Keohane and Nye had already popularized in the 1970s,[7] was another central element of Keohane's neoliberalism.

*After Hegemony* was also built on the school of functionalism*—a theory, founded on the argument that integration on the state level is driven by common interests, developed by the American political scientist Ernst B. Haas* to explain European integration.[8] Among the other key authors discussing the importance of the hegemon in international relations were the realist thinker Robert Gilpin* and the political economist Charles P. Kindleberger.* Keohane's book, therefore, condensed and brought order to ideas that were being proposed and discussed by many thinkers.

## The Contemporary Debate

*After Hegemony* reinforced Keohane's position as one of the central figures in the debate between neorealists and neoliberals. Neorealists such as the political scientists Robert J. Art,* Joseph M. Grieco,* and

Kenneth Waltz continue to disagree with Keohane's views on cooperation among states. Neoliberals such as the political scientists Robert Axelrod* and Lisa Martin,* meanwhile, build their work around the ideas developed in *After Hegemony*. Although the debate is yet to be settled, it is fair to say that it is not as central to international relations as it was in the 1980s.

Today, neoclassical realism*—a school of thought that argues that the structure of the international system, perceptions of this structure, and domestic developments determine state behavior—is the most active realist school of thought confronting neoliberalism. Neoclassical realism draws on both neorealism (a school founded on the theory that state behavior is decided by the structure and constraints of the international system) and traditional realism* (a school founded on the theory that international politics are defined by competition among states seeking to achieve relative gains). Although neoclassical realism focuses on structural explanations of state behavior, it does acknowledge that ideology and domestic factors help to explain it.

Neorealism may still be widely used by international relations scholars, but it is neoliberalism that continues to be the main liberal theory of international relations. Today neoliberalism and realism are understood to be different explanations of relations among states.

## NOTES

1    See Robert Powell, "Anarchy in International Relations Theory: The Neorealist-Neoliberal Debate," *International Organization* 48, no. 2 (1994): 313–44.

2    Daniel Maliniak et al., *TRIP Around the World: Teaching, Research, and Policy Views of International Relations Faculty in 20 Countries* (Williamsburg, VA: Teaching, Research, and International Policy (TRIP) Project, 2012), 27.

3    Kenneth Waltz, *Theory of International Politics* (New York: McGraw Hill, 1979), 88–9.

4    Waltz, *International Politics*,194–210.

5    "Theory Talk #9: Robert Keohane," Theory Talks, May 29, 2008, accessed May 26, 2013, http://www.theory-talks.org/2008/05/theory-talk-9.html.

6    Stephen D. Krasner, "Structural Causes and Regime Consequences: Regimes as Intervening Variables," *International Organization* 36, no. 2 (1982): 186.

7    Robert O. Keohane and Joseph S. Nye, *Power and Interdependence: World Politics in Transition* (Boston: Little, Brown, 1977), 1.

8    See Ernst B. Haas, *The Uniting of Europe: Political, Social, and Economic Forces, 1950–1957* (Stanford: Stanford University Press, 1958).

# THE AUTHOR'S CONTRIBUTION

## KEY POINTS

- Keohane tries to show that cooperation among states is possible even without the support of a dominant power, or "hegemon."*

- *After Hegemony* challenges neorealist* thought, presents a neoliberal* theory, and finally applies that theory to real-world case studies.

- Keohane's book was published in the context of debates between neorealism* and neoliberalism* about how best to explain relations among states.

### Author's Aims

Robert O. Keohane's main aim in *After Hegemony* was to show that cooperation among states in the absence of a hegemon (dominant power) is possible.[1] Keohane also wanted to show how the international institutions known as "regimes"* help with this cooperation, even if states tend to act in their own self-interest. The book is almost entirely devoted to this purpose.

By focusing on showing that cooperation is possible even if there is no hegemon, Keohane was trying to challenge the neorealist notion that cooperation exists primarily because the hegemon can benefit from it. He wanted to show that actors (states) seeking to obtain absolute gains* were able to cooperate to maximize their power, even if there is no hegemon forcing them to do so.

More broadly, Keohane wanted to explain why the relative decline of the United States in the 1970s—especially following the collapse of the Bretton Woods* system of international monetary management—

> **66** Without ignoring the difficulties that beset attempts to coordinate policy in the absence of hegemony, this book contends that non-hegemonic cooperation is possible, and that it can be facilitated by international regimes. **99**
>
> Robert O. Keohane, *After Hegemony: Cooperation and Discord in the World Political Economy*

would not lead to confrontation, at least not in the Western bloc.*

Keohane believed that international regimes initiated during the period of American hegemony* would survive the end of this hegemony thanks to the cooperative behavior they had helped to develop and sustain. He wanted to show that while there were many theoretical elements to the book, there was real-world evidence of the validity of these theories.

## Approach

Keohane divided his arguments in *After Hegemony* into three main sections and a conclusion. The first section—chapters 1 to 3—lays out the key ideas behind the neorealist model of international relations,* the principle alternative theoretical model to neoliberalism, including neorealist conceptions of how the international system is supposed to work and the supposed need for a hegemon to help facilitate cooperation.

The second section—chapters 4 to 7—contains Keohane's explanation of why and how cooperation can result from the existence of international regimes even in the absence of a hegemon and regardless of whether states have perfectly matching goals. This section sets out the main assumptions of Keohane's neoliberal theoretical model for analyzing international relations.

The third section—chapters 8 to 10—investigates these ideas in

practice by analyzing how cooperation worked after World War II,*
following the decline of American hegemony from the mid-1960s, in
the context of the trade and monetary regimes of advanced
industrialized countries, and in the context of the lack of a regime
governing oil trading during the 1970s.* The final section sets out
Keohane's conclusions.

Keohane engages directly with previous scholarship on the subject
rather than constructing a new theory without taking into account
other views or context. To address the question of whether
international cooperation is feasible in the absence of a hegemon,
Keohane unpicks and criticizes the neorealist argument that
cooperation in such circumstances is almost impossible because states
are inherently self-interested. His primary target here is the political
scientist Kenneth Waltz* and his *Theory of International Politics* (1979).
Keohane then provides a neoliberal theory that explains why
cooperation *can* exist in the absence of a hegemon, set out in such a
way that the two different theories can be easily compared. Finally,
Keohane tests this theory in practice, making sure that evidence-based
chapters examining a series of case studies follow on from the previous,
theory-building section. His approach to dismantling the key elements
of neorealism, then, is scientific and systematic, constructed so that he
cannot be accused of focusing on some aspects of neorealism while
conveniently overlooking others, and also focusing on the inner
workings of the international system.

## Contribution in Context

Keohane is successful in doing what he set out to do in *After Hegemony*.
The book develops the basic ideas of neoliberalism, making clear why
it is a valid theoretical explanation of international politics. The book
clearly defends the idea that cooperation among states does not
depend on the presence of a hegemon. Keohane's argument is that
cooperation results from the existence of international regimes that

encourage collaboration by creating stability and by reducing both uncertainty about the behavior of other states, and the charges incurred when making international transactions.[2] Keohane's research built on ongoing studies into the role that international regimes play in promoting cooperation such as those of the international relations scholars Joseph S. Nye, Jr.* and John Ruggie.* Indeed, the journal *International Organization*, consistently ranked as one the most cited international relations journals by the Social Sciences Citation Index (SSCI),[3] published a special issue[4] on international regimes less than two years before Keohane published his book in 1984. Authors such as the political scientist Ernst B. Haas* and the scholars Stephen D. Krasner* and Oran R. Young* contributed to this volume. This shows that *After Hegemony* was part of a broader discussion on cooperation in international politics.

## NOTES

1   Robert O. Keohane, *After Hegemony: Cooperation and Discord in the World Political Economy* (Princeton: Princeton University Press, 1984), 9–10.

2   Keohane, *After Hegemony*, 53.

3   For a list of international relations journals covered by the SSCI, see http://science.thomsonreuters.com/cgi-bin/jrnlst/jlresults.cgi?PC=SS&SC=OE.

4   Benjamin, J. Cohen, et al., *International Organization* 36, no. 2 (1982): 185–510.

# SECTION 2
## IDEAS

# MAIN IDEAS

## KEY POINTS

- *After Hegemony* argues that international regimes* help states to cooperate, even without the influence of a hegemon*—a dominant power.

- Keohane proposes that the main drivers behind cooperation are rational choice,* functionalism,* and bounded rationality.*

- The work has a coherent structure and clear language, making it easy to follow.

### Key Themes

In *After Hegemony* Robert O. Keohane explores whether cooperation among states is possible in the absence of a hegemon and, if so, how.

He defines hegemonic powers as those having "control over raw materials, sources of capital, control over markets,* and competitive advantages in the production of highly valued goods."[1] In Keohane's view, hegemonic structures provide leadership that other independent states consent to, having come to the conclusion that the arrangement is to their benefit. In *After Hegemony*, Keohane demonstrates that it is possible for states to cooperate without a hegemon since nations with shared financial and trading interests increasingly find that interdependence is to their benefit.

The main themes of *After Hegemony* are:
- The review of hegemonic power systems
- The facilitation of non-hegemonic cooperation by international regimes
- The decline of power in the United States in the final quarter of the twentieth century.

> ❝ When shared interests are sufficiently important and other key conditions are met, cooperation can emerge and regimes can be created without hegemony. ❞
>
> Robert O. Keohane, *After Hegemony: Cooperation and Discord in the World Political Economy*

Exploring these three themes, Keohane built on pre-existing and ongoing political thought and international relations* scholarship, especially idealism* (the school of thought that international politics can be defined by peace and cooperation if states seek to achieve relative* rather than absolute gains)* and neoliberalism.* His work was unique, however, in the way the book treats these key themes: *After Hegemony* offered a coherent, systematic theory of international relations and neoliberalism, designed to go beyond any particular place or time.

## Exploring the Ideas

*After Hegemony* can be understood as an argument against neorealism.* Neorealism claims cooperation requires a hegemon and that this is the only way cooperation can be guaranteed without states competing to become the hegemon themselves. Keohane was dissatisfied with this explanation of cooperation, having observed the United States during a period of apparent decline in the late 1970s.

While acknowledging that the international system could be characterized by anarchy*—a potentially chaotic lack of any governing authority—Keohane argues that cooperation is possible, thanks to the existence of international regimes, that is, agreed norms, principles, and decision-making procedures, which give states the incentive to create institutions that foster cooperation and reduce the likelihood of discord.

Keohane suggests that international regimes evolve from situations

in which states have already concluded that cooperation is desirable and, even if the regime had been created when there was a hegemon in place, they would survive the decline of the hegemon itself, given the benefits the regime could offer. In essence, international regimes create cooperative situations by adjusting the expectations of their members until they find a mutually satisfying expectation. This process brings together self-interested states that would otherwise find it difficult to sustain regular cooperation.

Keohane's themes emerge out of a discussion of the flaws of neorealism, in which he lays out the main elements of neoliberal* theory. Keohane combines these concepts to support neoliberalism's claims about cooperation.[2] First, he explains the flaws behind realism's view that cooperation is occasionally possible and almost never occurs in the absence of a hegemon, while pointing out that there is, in fact, good evidence to show that cooperation often occurs in the absence of a hegemon.[3] For example, cooperation in the areas of trade and monetary policy survived the decline of the United States as a hegemon because states were able to keep cooperating using international bodies such as the United Nations* or the Bretton Woods* system. According to Keohane, realist claims that cooperation without a hegemon does not exist, then, cannot be entirely credible.

Second, Keohane makes it clear that cooperation can exist as long as there are international regimes bringing states together. He proposes that there are three main drivers behind cooperation:

- Bounded rationality—the idea that rational behavior occurs within the limits of the information available to us, our capacity to process it, and by the time it takes to make a decision based on what we understand
- Rational choice—the decisions we make to further our own interests
- Functionalism—the theory that common interests drive integration based on similar decisions.[4]

Keohane explains rational choice as the opportunity for states to engage in cooperation if it allows them to maximize their own power and wealth. The cost-effectiveness of international regimes facilitating cooperation makes them attractive to those states that may otherwise refuse to cooperate for selfish reasons. Moreover, the principles, rules, and procedures that international regimes create are attractive to rational states, because they help establish predictable behavior in other states. Finally, Keohane explains that through bounded rationality, international regimes increase the information that their members have about specific issues and also the positions held by other members. Since decisions taken by states are invariably affected by bounded rationality, members of a regime will value both the supplementary information the regime gives them and the limits the regime imposes on the behavior of other states.

## Language and Expression

Keohane divides *After Hegemony* into three main parts. In the first part, he discusses neorealism and hegemony* in international relations, with special reference to the world economy. In the second part, Keohane analyses regime-based cooperation and focuses on rational choice, functionalism and bounded rationality—the three key drivers that make it easier for regimes to cooperate. In the third part, the author uses observable evidence to analyze post-hegemonic cooperation concerning trade and money, which he contrasts with non-cooperation concerning oil.

*After Hegemony*'s coherent structure offers a great example of how international relations can be a social science. Keohane first presents and analyses a theory that he seeks to disprove—neorealism. He then presents his own theory—neoliberalism—laying it out through a detailed explanation founded on an engagement with the theory he wishes to disprove (neorealism). Finally, Keohane tests his theory through case studies, as we have just seen. In this way, Keohane

develops a neoliberal explanation of international relations, both in theory and in practice.

Although Keohane uses terms that are common in the field of international relations, the text sets out theoretical principles in a clear and organized way so as not to overwhelm the reader with (social) scientific jargon. This makes the book easily accessible to a general audience, while still being extremely interesting to experts and scholars interested in international relations.

The fact that Keohane received the second-ever Grawemeyer Award for Ideas Improving World Order[5]—a lucrative award bestowed by the University of Louisville in the United States—largely in response to the themes developed in *After Hegemony*, proves his ability to reach beyond a specialized audience, while also developing a theoretically rich analysis of relations among states.

## NOTES

1    Robert O. Keohane, *After Hegemony: Cooperation and Discord in the World Political Economy* (Princeton: Princeton University Press, 1984), 32.

2    Keohane, *After Hegemony*, 32.

3    Keohane, *After Hegemony*, 32.

4    Keohane, *After Hegemony*, 32.

5    "After Hegemony: Cooperation and Discord in the World Political Economy," Princeton University Press, accessed January 4, 2015, http://press. princeton.edu/titles/1322.html.

# MODULE 6
# SECONDARY IDEAS

## KEY POINTS

- A secondary theme in *After Hegemony* refers to reasons why states construct and respect international regimes.* Specifically, they create rules and show how the interests of different states are similar.

- Post-hegemonic cooperation is underpinned by expectations that regimes will lead states to abide by their rules and redefine their own self-interest.

- *After Hegemony*'s chapter on the oil regime of the 1970s has been relatively neglected.

### Other Ideas

An important secondary idea in Robert O. Keohane's *After Hegemony* is the question of why states build international regimes in the first place, and decide to abide by their rules. Keohane suggests that there are principally two reasons. First, international regimes create rules that other states are expected to abide by, and will respect in the future, even if there is a change in government.[1] According to neoliberalism,* rules are essential for a regime to operate because they identify expectations of behavior and define the principles on which a regime rests. For example, in the case of a trade regime, it is expected that participating states will abide by the rules of not imposing tariffs on imported goods to weigh trade in their favor—and that they will be sanctioned if they do. Significantly, regimes create long-term commitments that future governments of member states must follow. This means that the future is more predictable, because rules will be respected even if there is a change in government.

> ❝ Architects of regimes anticipate that the regimes will facilitate cooperation. Within the functional argument being constructed here, these expectations explain the formation of the regimes. ❞
>
> Robert O. Keohane, *After Hegemony: Cooperation and Discord in the World Political Economy*

Second, international regimes develop through the understanding that participating states are similarly self-interested. So states build regimes and abide by their rules for both selfish and sympathetic reasons. This combination strengthens international regimes, because they rely on a combination of coercion and an understanding that states have similar interests.[2] Although states share the goal of maximizing their own power and wealth, this self-interest does not necessarily lead to conflict and can be served in many different ways. Cooperation in international regimes can help states achieve these goals. As long as international regimes are a more cost-effective means of increasing power and wealth than other alternatives, then states will opt for them.

Keohane also suggests that the regular interaction encouraged by international regimes results in empathy developing between states. Well-functioning regimes and those around them will benefit from this empathy. Others will eventually realize that the maximization of power and wealth can be achieved through other states in the regime maximizing their own power and wealth as well. While self-interest does not entirely disappear, it is supplemented by an interest in another state improving its own situation too.

### Exploring the Ideas

By employing theories of rational choice,* functionalism,* and bounded rationality,* Keohane clarifies why international regimes are

built on the rational expectation that states will abide by their rules, with functionalism laying out how those regimes can strengthen everybody's interests being interlinked. Bounded rationality is then used to explain how international regimes influence the expectations of states.[3]

The secondary idea related to the interaction between egoism and empathy, meanwhile, is developed in detail in chapter 7. While explaining why and how bounded rationality helps foster cooperation, Keohane argues that it also leads to a redefining of self-interest. Crucially, a redefinition does not imply that self-interest disappears. Rather, self-interest is redefined so as to include the notion that what is beneficial for one member of the regime is also beneficial for the others. This is where self-interest brings selfishness and empathy together. A state contributing to the maintenance of a regime is still pursuing its self-interest—but it understands that its self-interest should incorporate the interests of other parties in the regime, too.[4]

This secondary theme also underpins the book's key themes and in this way the work's overall argument becomes greater than the sum of its parts. Without including this subordinate idea, Keohane's book would have been less convincing in presenting the bigger case for neoliberal* thought.

## Overlooked

*After Hegemony* is one of the most widely read and referenced international relations* books of the past 30 years.[5] Its main ideas and claims have been discussed in detail. Nonetheless, chapter 10, "The Consumers, Oil Regime, 1974–81,"[6] has received less attention than the rest of the book. This is understandable, because the chapter presents a specific case study to support the book's argument. Since almost all scholars discussing *After Hegemony* have engaged with its theoretical rather than its empirical content, most of them have not considered it necessary to discuss this case study. The chapter's

particular focus—the failure by advanced industrialized countries to create a well-functioning oil regime following the oil crises* of the 1970s—also makes it unlikely that it will receive more attention in the near future. Were there to be a focus on this neglected chapter, it would likely be in relating it to one of the main concerns of contemporary international politics: how to ensure energy security.

Cooperation among oil consumers has been uneven at best since the period covered in Keohane's chapter. Focusing on the period of relative cooperation prior to the 1970s and the period of non-cooperation between 1974 and 1981—as Keohane did in chapter 10 of *After Hegemony*—would strengthen the argument that the presence of a hegemon* is not the main reason why states cooperate. A hegemon was not necessary for states to cooperate in the trade and monetary regimes, but it *was* necessary for cooperation among oil consumers. So we must consider factors other than hegemony* to explain why cooperation does or does not occur.

Meanwhile, the intense scrutiny that *After Hegemony* has received since it first appeared in 1984 means it is unlikely that its content or significance will be reconsidered in the coming years. Cooperation through international regimes is one of the main characteristics of contemporary international politics. Keohane powerfully argued that both international regimes and cooperation are possible with (or, more importantly, *without*) a hegemon.

Since Keohane wrote his book, there have been periods of American-Soviet* bipolarity* (that is, international dominance has been shared), US hegemony, and also a decline of American power due to the rise of China. This rise has been clearest in the economic field. And yet cooperation as a result of the work of international regimes has continued. In this context, it is not particularly likely that Keohane's work will be reconsidered.

## NOTES

1    Robert O. Keohane, *After Hegemony: Cooperation and Discord in the World Political Economy* (Princeton: Princeton University Press, 1984), 116–7.

2    Keohane, *After Hegemony*, 123–4.

3    Keohane, *After Hegemony*, 65–132.

4    Keohane, *After Hegemony*, 110–132.

5    See Google Scholar, JSTOR and other academic search databases.

6    Keohane, *After Hegemony*, 217–40.

# ACHIEVEMENT

## KEY POINTS

- *After Hegemony* helps us to understand better the reasons why states cooperate—a theme explored by Keohane in previous works.

- Keohane's book has been very influential in the field of international relations,* and it still has an impact on this social science today.

- The main limitation of this work—its offer of a "grand theory"* that is not universally applicable—is a problem with the social sciences in general.

### Assessing the Argument

The ideas presented by Robert O. Keohane in *After Hegemony* that offer an alternative to neorealism* are useful to academics, students, people interested in international relations, and policymakers alike. The debate between neoliberalism* and neorealism became one of the key features of international relations during the 1980s, with Keohane and the political scientist Kenneth Waltz*—the father of neorealism—being the main drivers of these two differing viewpoints.

Furthermore, international relations scholars and other social scientists have found the discussion of international regimes* and cooperation useful to our understanding of the reasons why states work together both to foster global governance,* and to put rules and regimes in place in order to solve problems. For students of international relations, *After Hegemony* is an essential introductory text to understand neoliberalism and international politics theory. Policymakers, meanwhile, find that *After Hegemony* contributes to our

> **❝** Yet institutions are often worth constructing, because their presence or absence may determine whether governments can cooperate effectively from common ends. It is even more important to seek to maintain the valuable international institutions that continue to exist … if they did not exist, many of them would have to be invented. **❞**
>
> Robert O. Keohane, *After Hegemony: Cooperation and Discord in the World Political Economy*

understanding of how cooperation among states might be encouraged.

Keohane's ideas can be traced back to his earlier works. Two in particular stand out. In 1977, Keohane and Joseph S. Nye, Jr.* published *Power and Interdependence: World Politics in Transition*, a work which explained how international regimes affect state behavior and evolve by creating interdependence among actors. Regimes create links among actors that are capable of going beyond simple government control.[1] Later, in 1982, Keohane published the article "The Demand for International Regimes," which argued that rational choice* theory helped explain why self-interested actors could create international regimes.[2] Examples of such regimes are those created to combat the proliferation of weapons of mass destruction, or to fight climate change. This is a central aspect of the argument Keohane later made in *After Hegemony*.

Keohane's ideas and themes, therefore, built on both the traditional idealism* underpinning much previous work on international relations, including his own. At the same time, they were part of a greater body of work being produced by Nye and other international relations scholars writing on international regimes and cooperation during the 1970s and 1980s.

## Achievement in Context

*After Hegemony* is still an influential book, as are other works either written or co-edited by Keohane. Neoliberalism continues to be one of the three main theoretical approaches to the study of international relations, along with neorealism and constructivism*³—an approach founded on the idea that since international relations are socially constructed, interactions are the result of the ways in which states understand themselves and others.

As for Keohane, he is considered the second most influential international relations scholar of the past 20 years after the political scientist Alexander Wendt.*⁴ To a large extent, this is probably the result of the continuing relevance of *After Hegemony* and related works he has subsequently published. *After Hegemony* has been cited almost 8,000 times to date, which is an impressive tally for a work on the subject.

Overall, *After Hegemony* and these related works have helped Keohane to become one of the defining figures of contemporary international relations, and to become influential even beyond this field. His ideas about how cooperation in the absence of a hegemon* can exist, and how international regimes help collaboration among states, continue to be debated and tested. Furthermore, the perceived decline of the United States as a hegemonic power since the turn of the millennium has reignited interest in the role of international regimes in fostering cooperation among states. Following a brief period of increased American power in the 1990s, there is a perception that China—and other emerging powers such as Brazil, Iran, or India—might challenge American dominance. As a result, there are debates in the United States, the European Union,* and elsewhere about how these powers might be integrated into existing international regimes. A new edition of Keohane's *After Hegemony* was published in 2005, showing that it is still relevant in the context of these debates.

## Limitations

In writing *After Hegemony*, Keohane wanted to create a theory of international relations that would be applicable regardless of time and place. Certainly, his theory has withstood the test of time relatively well. International regimes continue to be created and many countries continue to respect them. In spite of there not being a definite hegemon today, international regimes have nonetheless become a central feature of international relations.

Nevertheless, it could be argued that there is a limitation in this book. Although it is grounded in the analysis and interpretation of observable evidence according to scientific methods, *After Hegemony* does flirt with becoming a "grand theory"—that is, it hints at a universal quality that it does not necessarily possess.

The theory of neoliberalism presented by Keohane cannot be applied to all cases. Indeed, there are examples of regimes malfunctioning, as in the case of Iraq in the early 2000s, where the administration of US President George W. Bush* accused the Iraqi regime of possessing weapons of mass destruction. This turned out not to be the case. The international financial regime failing to prevent a global recession in 2007 to 2011—the purpose it was specifically set up to prevent—is another clear example.

Even though Keohane tried to minimize the limitations of his theory, he did this by following the social scientific method, which ultimately meant he was trying to overcome one of the greatest shortcomings of social science. Social scientists analyze human beings and society rather than nature. Therefore, social scientific findings are not as easy to generalize as the findings from natural science, given that human beings and society do not act following fixed patterns.

## NOTES

1    Robert O. Keohane and Joseph S. Nye, *Power and Interdependence: World Politics in Transition* (Boston: Little, Brown, 1977), 21.

2   Robert O. Keohane, "The Demand for International Regimes," *International Organization* 26, no. 2 (1982): 325–55.

3   Daniel Maliniak et al., *TRIP Around the World: Teaching, Research, and Policy Views of International Relations Faculty in 20 Countries* (Williamsburg, VA: Teaching, Research, and International Policy (TRIP) Project, 2012), 49.

4   Maliniak et al., *TRIP Around the World*, 49.

# MODULE 8
# PLACE IN THE AUTHOR'S WORK

## KEY POINTS

- Keohane continued developing neoliberalism* after the publication of *After Hegemony*, both as a theory and in actual analysis of its application.

- *After Hegemony* sits as the most important book in Keohane's overall body of work.

- Keohane is still considered to be a central figure in international relations.*

### Positioning

Following the 1984 publication of *After Hegemony*, Robert O. Keohane continued to refine neoliberalism as a theory of international relations. His work falls neatly in the neoliberal* school of thought. Works such as *Power and Governance in a Partially Globalised World* (2002) and *Legalization and World Politics* (2001), co-edited with the political scientist Judith L. Goldstein,* build upon the key themes of neoliberalism laid out in *After Hegemony*.

Keohan's thinking about neoliberalism has evolved, but this is not surprising considering the changes in the international system since 1984, the year the book was first published. Indeed, the end of the Cold War* (a decades-long period of great diplomatic tension between the United States and its allies and the Soviet Union* and its allies) and the economic rise of countries such as China, have shifted the international system from a bipolar* world (that, is a world where dominance is shared by opposing powers) to a unipolar* or multipolar* one—depending on one's perspective. However, Keohane's main body of work still revolves around the idea that

> ❝ The theory presented here is relevant to any situation in world politics in which states have common or complementary interests that can only be realized through mutual agreement. ❞
>
> Robert O. Keohane, *After Hegemony: Cooperation and Discord in the World Political Economy*

international regimes* do foster cooperation among states, regardless of the presence of a hegemon* or otherwise.

Building on his own theoretical contributions to the field of international relations, Keohane has also developed work on particular regimes. Most notably, he has built on the empirical chapter on the oil regime—or lack of—of the 1970s included in *After Hegemony*. He has written about the evolution of the energy regime[1] and closely related regimes such as the one centered on climate change.[2] With this work, Keohane has moved beyond grand theory* and concepts and into specific case studies and empiricism,* or observable evidence. As a result, his body of work has become more holistic, bringing theory and practical analysis more closely together.

Recently, Keohane has also been engaged in debates about the nature of the power of the United States, and whether it remains a hegemon. This is an ongoing debate among scholars and practitioners of international relations.

When Keohane wrote *After Hegemony*, the bipolarity that characterized the Cold War was a key feature of the international system. But the collapse of the Soviet Union and the emergence of America as the sole superpower*—a hegemon—has changed the nature of the debate. This situation appears to have ended in the early 2000s, however, following the 9/11* terrorist attacks on the United States.

Since then, the US has started two costly interventions in Afghanistan and Iraq, a global War on Terror,* and has been wracked

by an economic crisis that began in 2007. The same period saw China emerge as a major economic and industrial powerhouse, which raised questions of whether it was capable of challenging American hegemony.* In recent publications, Keohane has been undecided as to whether the United States continues to be a hegemon today. Even if it is not, however, he still believes that it will carry on playing a central role in global affairs.[3]

## Integration

Although *After Hegemony* was the first work Keohane wrote alone, it was not his first publication. This was *Power and Interdependence*, which he co-authored with the political scientist Joseph S. Nye, Jr.* in 1977. *Power and Interdependence* was a text that firmly established the two as proponents of the neoliberal school of thought in international relations. Although neoliberal thought first emerged as an economic theory as long ago as the 1930s, Keohane and Nye's contribution was to apply its central principles to international relations theory.

In the 40 years between 1966 and 2006, Keohane published 39 articles or book chapters, edited or co-edited 13 books and co-authored three books, among other works on single subjects. It took him seven years to write *After Hegemony* and in that time he also managed to publish seven articles in prestigious academic journals. This is an impressive academic output.[4] In the context of so many publications, *After Hegemony* is a mid-career publication—but clearly the work of a mature thinker. Keohane's body of work offers support, derived from observable evidence, of the neoliberal argument that regimes facilitate cooperation among states whose respective self-interests might be reconcilable. Indeed, many of Keohane's publications have looked to apply and then refine neoliberalism as a theoretical model, particularly following the end of the Cold War. In 2012, Keohane published the article "Hegemony and After" in the international relations journal *Foreign Affairs*. In it, he argued that the

decline of American power should not prevent nations from cooperating, as long as international regimes still function.[5] Evidently, Keohane still believes in the neoliberal theory he presented over 30 years ago.

### Significance

Keohane's work as an international relations theorist has gained him considerable respect in his field of study. *International Organization*, one of the top international relations journals and home to important debates between neorealist* and neoliberal scholars in the 1980s and 1990s, has established an annual Robert O. Keohane Award for the best young scholar to publish on international organizations.[6] This award is a testament to the importance of Keohane's body of work to the field of international relations.

Of all his publications, *After Hegemony* is by far his most successful. When Keohane received the prestigious Harvard Graduate School of Arts and Sciences Centennial Medal in 2012, he was described as one of "the most influential and respected theorists of world politics and power" and "a founding father of the modern field of international political economy," a subfield of international relations.[7]

Google Scholar, meanwhile, indicates that *After Hegemony* has been cited in academic journals more than 8,000 times at the time of writing,[8] making it one of the most successful books in the field of international relations. The only text on international relations theory that has been more successful than *After Hegemony* is Kenneth Waltz's *Theory of International Politics* (1979), which has been cited nearly 12,000 times.[9]

## NOTES

1   Jeff Colgan et al., "Punctuated Equilibrium in the Energy Regime Complex," *The Review of International Organizations* 7, no. 2 (2012): 117–43.

2   Robert O. Keohane and Kal Raustiala, "Towards a Post-Kyoto Climate Change Architecture: A Political Analysis," in *Post-Kyoto International Climate Policy: Implementing Architectures for Agreement*, edited by Joseph E. Aldy and Robert N. Stavins (Cambridge: Cambridge University Press, 2009), 372–400.

3   Robert O. Keohane, "Hegemony and After: What Can Be Said about the Future of American Leadership?" *Foreign Affairs* 1, no. 4 (2012): 1–5.

4   "Curriculum Vitae," Princeton University, accessed January 4, 2015, http://www.princeton.edu/~rkeohane/cv.pdf.

5   See Keohane, "Hegemony and After."

6   See "The Robert O. Keohane Award," Cambridge Journals, accessed July 10, 2015, http://jnls.cup.org/journal.do?jid=INO#.VZ5devlViko.

7   "Harvard Graduate School Honors Daniel Aaron, Nancy Hopkins and Others," *Harvard Magazine*, May 23, 2012, accessed March 31, 2015, http://harvardmagazine.com/2012/05/harvard-graduate-school-centennial-medalists-2012.

8   "Robert Keohane, *After Hegemony*," Google Scholar, accessed on May 13, 2015. https://scholar.google.com/scholar?cites=560052273688874574&as_sdt=20005&sciodt=0,9&hl=en.

9   "Kenneth Waltz," Google Scholar, accessed May 19, 2015, https://scholar.google.com/scholar?cluster=7694130487730532041&hl=en&as_sdt=0,9.

# SECTION 3
# IMPACT

# THE FIRST RESPONSES

## KEY POINTS

- *After Hegemony* has been criticized for its lack of analysis of domestic politics and for failing to properly explain how gains from cooperation are distributed.
- Keohane has been willing to engage with his critics to defend his arguments.
- Ultimately, it is generally agreed that neorealist* and neoliberal* thought can co-exist.

### Criticism

Robert O. Keohane's *After Hegemony: Cooperation and Discord in the World Political Economy* has been the subject of three main criticisms.

First, a common criticism of neoliberalism* in general—and including *After Hegemony*—comes from international relations* scholars such as Jeffrey Checkel,* who subscribe to neither neorealist nor neoliberal viewpoints. Checkel argued that the differences between neorealism* and neoliberalism were minimal, since both believe that the international system is anarchical in nature, assume that states are self-interested, and argue that cooperation is possible under certain circumstances.[1]

A second, and perhaps more pertinent criticism, is that *After Hegemony* fails to take into account domestic politics. This critique is valid as domestic politics never really features in Keohane's analysis—but it should be noted that his field is international relations, not international-domestic relations. With the end of the Cold War* following the collapse of the Soviet Union* in 1989, the influence of domestic politics on state behavior became a more popular area of

> **❝** By and large, the constructivists under review would concur with such a characterization [of world politics]. Their critique of neorealists and neoliberals concerns not what these scholars do and say but what they ignore: the content and sources of state interests and the social fabric of world politics. **❞**
>
> Jeffrey T. Checkel, "The Constructive Turn in International Relations Theory"

inquiry as an increasing number of scholars felt free to focus on areas other than the rivalry of states that defined the Cold War. As more data on domestic politics from a greater number of countries became available, meanwhile, new theoretical approaches pointed out the importance of domestic aspects of decision-making processes.[2]

Moreover, criticism of the book on the basis that it does not pay sufficient attention to domestic politics, or on the similarities between neorealism and neoliberalism, comes from authors who ground their arguments in other theoretical perspectives. They do not necessarily mean that Keohane's arguments are wrong. They emphasize, rather, aspects of international politics that *After Hegemony* and neoliberalism do not necessarily focus on.

## Author's Response

Robert O. Keohane's initial response to criticism of *After Hegemony* was to refine his arguments, explaining aspects that might not have been sufficiently clear in the original text. Along with Joseph S. Nye, Jr.,* co-author of *Power and Interdependence* (1977), Keohane explained the benefits of multilateralism* for all states in general but, more crucially, for superpowers.*[3] In addition, he investigated how cooperation need not impinge on sovereignty* or affect a state's desire to be self-interested.[4] More generally, Keohane reiterated why the

study of international regimes* was necessary, regardless of one's theoretical and methodological approach to international relations.[5] Keohane was open to discussing the merits of neoliberalism in general, and *After Hegemony* in particular.

Following its publication, there was a critical dialogue on the similarities and differences between neorealism and neoliberalism. In the introduction to an edited volume on neorealism, Keohane emphasized that theory was necessary to understand international politics and that neorealism offered a persuasive explanation of state behavior.[6] This showed his willingness to recognize that other theories were valid to the study of international relations. Indeed, following the end of the Cold War, and seven years after the publication of *After Hegemony*, Keohane was willing to explore how neorealism and neoliberalism affected each other,[7] despite the perception that the collapse of the Eastern bloc* was a victory for liberalism.*

## Conflict and Consensus

Ultimately, neither neorealism nor neoliberalism can claim to be definitive. Instead, we must continue to think of them as theories. Cooperation, as neoliberal thought argues, has been a feature of international politics for centuries, even in the absence of a hegemon.* As much as neorealist theory is often understood to be in opposition to neoliberal thinking, it does not argue that cooperation is impossible; it merely states that it is difficult to achieve and to maintain, particularly in the absence of a hegemon who will most benefit from cooperation and will therefore urge this course out of self-interest. Indeed, there are scholars who maintain that neoliberalism and neorealism are not too dissimilar. They can be said to be committed to a rationalist analysis of international relations that gives central roles to states, assumes that the international system is anarchical,* and shares an emphasis on the usefulness of international institutions.[8] Therefore, neorealism's criticism of neoliberalism in general, and Keohane's work in particular,

is not based on a fundamental disagreement about the nature of international relations, but rather on how it is understood.

Acknowledgement of criticism of his work did not lead Keohane to modify his opinions, however. In articles, books and other publications released in the years after the publication of *After Hegemony*, Keohane refined his argument, but did not alter it.

Furthermore, the second edition of *After Hegemony*, published in 2005, remained unchanged apart from a new preface.

## NOTES

1   See Jeffrey T. Checkel, "The Constructive Turn in International Relations Theory," *World Politics* 50, no. 2 (1998): 324–48.

2   Stephan Haggard, "Book Review: After Hegemony: Cooperation and Discord in the World Political Economy," *Worldview Magazine* 28, no. 4 (1985): 25–6.

3   Robert O. Keohane and Joseph S. Nye, Jr., "Two Cheers for Multilateralism," *Foreign Policy* 60, no.1 (1985): 148–67.

4   Robert O. Keohane, "Reciprocity in International Relations," *International Organization* 40, no. 1 (1986): 1–27.

5   Robert O. Keohane, "International Institutions: Two Approaches," *International Studies Quarterly* 32, no. 4 (1988): 379–96.

6   Robert O. Keohane, "Realism, Neorealism and the Study of World Politics," in *Neorealism and Its Critics*, edited by Robert O. Keohane (New York: Columbia University Press, 1986), 1–26.

7   Robert O. Keohane, "Institutional Theory and the Realist Challenge After the Cold War," in *Neorealism and Neoliberalism: The Contemporary Debate*, edited by David A. Baldwin (New York: Columbia University Press, 1993), 269–300.

8   Filippo Andreatta and Mathias Koenig-Archibugi, "Which Synthesis? Strategies of Theoretical Integration and the Neorealist-Neoliberal Debate," *International Political Science Review* 31, no. 2 (2010): 207–27.

# MODULE 10
# THE EVOLVING DEBATE

## KEY POINTS

- *After Hegemony* was useful for international relations* scholars from the moment it was published, and continues to be so today.
- New variations of realism* are still challenging, and being challenged by, *After Hegemony* and liberalism.*
- Contemporary debates between neorealism* and neoliberalism* are mostly intellectual.

### Uses and Problems

In the years following its 1984 publication, Robert O. Keohane's *After Hegemony: Cooperation and Discord in the World Political Economy* was key to the evolution of international relations as a field of inquiry. Although the theoretical debate between neoliberalism and neorealism began before the publication of *After Hegemony*, the book could be considered the first text to present the neoliberal case clearly and in detail. Much of the neoliberal thought that followed it, therefore, was founded on the ideas it proposed—and the work became one of the focal points of neorealist critiques of neoliberalism.

Meanwhile, a new theoretical approach, constructivism*—a theory founded on the principle that since international relations are social constructions they can be explained by considering the ways states perceive themselves and others—became popular in the early 1990s. Constructivism engaged the ideas presented in *After Hegemony* and criticized the limitations of both neoliberalism and neorealism.

Keohane remains influential. As a leading neoliberal scholar, based at a prestigious school, he has taught his theory to hundreds of students,

> **❝** By seeking to specify the conditions under which institutions can have an impact and cooperation can occur, institutionalist theory shows under what conditions realist propositions are valid. It is in this sense that institutionalism claims to subsume realism. **❞**
>
> Lisa Martin and Robert O. Keohane, "The Promise of Institutionalist Theory"

and influenced many more in his field. More importantly, a number of political scientists, among them Charles Lipson,* Lisa Martin,* Kenneth Oye,* and Duncan Snidal,* who are all attached to prestigious centers of learning in the United States and the United Kingdom, have sought to refine Keohane's theory.[1] They accept neoliberalism's main points and have tried to apply his theory to specific concepts or to new case studies.

### Schools of Thought

Just over three decades after publication, *After Hegemony* is still relevant. The theoretical framework it offered fueled both an intellectual and a policy debate in the United States about the role international institutions played in fostering cooperation with the Soviet Union* and the wider Eastern bloc.* After the collapse of the Soviet Union in 1989, the United Nations* and other institutions became even more central to global governance* by leading initiatives in cooperation. In short, Keohane's call for international cooperation had an impact on how the United States viewed cooperation with its Cold War* opponent, the Soviet Union.

Cooperation among states has widened and broadened: new international regimes* have appeared in areas such as counterterrorism,* nuclear nonproliferation,* financial governance, and trade. These international regimes now include more states and cover more issues.

*After Hegemony's* ideas provide a theoretical basis for scholars studying global governance, international regimes, and international institutions. In particular, the debate over the need or otherwise of a global hegemon* to ensure cooperation in international regimes continues today. *After Hegemony* still plays an important role in this debate.

Keohane's text still engages with realism, both in its neorealist form and in its most recent reincarnations:

- Neoclassical realism*–a combination of neorealist and realist thought
- Offensive realism*–a theory developed out of the idea that the structure of international relations encourages states to behave aggressively, so increasing the likelihood of conflict
- Defensive realism*–a theory founded on the idea that the structure of international relations encourages states to think about their security, similarly increasing the likelihood of conflict.

Contemporary realist thinkers such as John Mearsheimer,* the founder of offensive realist theory, and the political scientists Randall Schweller,* Stephen Walt,* and William Wohlforth,* all maintain that cooperation among states is uncommon and extremely difficult to achieve without a hegemon. For them, this only occurs when it helps states achieve their self-interested goals. For Keohane, of course, self-interest is not the only consideration for states when they cooperate.

## In Current Scholarship

Today, a wide range of scholarship engages with the same issues discussed in *After Hegemony*. The debate between liberal-idealist* and realist interpretations of international affairs is nothing new; dating back to the 1920s, it has been a central feature of the theoretical landscape of international relations for decades. Today, the debates continue both in the academic world and in policy debates. These

debates tend to pit realists against idealists, in a general sense. This is certainly evident in policy debates following the end of the Cold War and after 9/11*—the terrorist attacks in the United States on September 11, 2001.

The debate in the public sphere between liberals and conservatives,* however, does not quite reflect the conflict in the academic world, where the opposing positions are neorealist and neoliberal. Constructivists, meanwhile, who claim that international relations are social constructs anyway, critique both. On the neorealist side of the debate are scholars like John Mearsheimer, Randall Schweller, Stephen Walt and William Wohlforth. For them, of course, cooperation in the absence of a hegemon is unlikely. On the neoliberal side of the debate are a group of prominent scholars who look to Keohane as a source of inspiration. These include the political scientists Robert Axelrod,* Charles Lipson, Lisa Martin, Kenneth Oye and Duncan Snidal.

Keohane's book has also influenced scholars working on international regimes and international institutions such as the political scientists Judith Goldstein,* Beth Simmons,* and Anne-Marie Slaughter.* A survey of international relations scholars conducted in 2012 estimates that 28 percent of the literature in the field draws on liberal thought. Only realism is more popular in the literature.[2] Neoliberalism is therefore a significantly influential approach to the field.

## NOTES

1  See Charles Lipson, "Why Are Some International Agreements Informal?" *International Organization* 45, no. 4 (1991): 495–538; Lisa L. Martin, "Interests, Power, and Multilateralism," *International Organization* 45, no. 4 (1992): 765–92; Kenneth Oye and James Maxwell, "Self-interest and Environmental Management," *Journal of Theoretical Politics* 6, no. 4 (1994): 593–624; Duncan Snidal, "Relative Gains and the Pattern of International Cooperation," *American Political Science Review* 85, no. 3 (1991): 701–26.

# MODULE 11
## IMPACT AND INFLUENCE TODAY

### KEY POINTS

- *After Hegemony* is still relevant today, despite changes in the international order.

- The book has informed debates beyond international relations,* most notably in international law.

- Keohane's work is useful for debates about the role of the United States in international affairs.

### Position

Robert O. Keohane's *After Hegemony: Cooperation and Discord in the World Political Economy* is still relevant over 30 years after publication; aside from a new preface, the second edition, published in 2005, was unchanged from the original. This is remarkable, given the extent to which international politics has changed since the book was first published in 1984. At that time, Japan and Germany were considered to be challengers to the economic dominance of the United States. By 1994, when only the United States was considered a superpower,* this was not the case. Today, China appears to be America's only hegemonic* challenge due to its growing economic wealth, industrial capacity, and military prowess. Despite this, however, cooperation among states continues to persist—thanks in large part to the role of international regimes.*

As the book's argument is founded on data drawn from the study of international, rather than domestic, affairs and politics, cultural contexts are not relevant. Furthermore, Keohane made clear that although he used a case study of Western industrialized countries to

> **❝** These works [*After Hegemony* and *Power and Interdependence*] set the stage for what has become a standard disciplinarian assumption about the phenomenon of economic interdependence ... Yet this assumption rests upon questionable, normative assumptions about individual cognition and domestic politics that have remained largely unexcavated. **❞**
>
> Jennifer Sterling-Folker, "Neoclassical Realism and Identity"

exemplify this argument, his reasoning was applicable far more generally.[1] Those who believe in neoliberal* thought do not consider their ideas to be a Western construct, only applicable to a single cultural context, and *After Hegemony* reflects this assumption.

### Interaction

*After Hegemony* is still particularly relevant in two ways. First, it continues to inform theoretical debates in the discipline of international relations as a key work that discusses one of the most popular theories of international politics. Second, Keohane's book still defines discussions surrounding the question of why states cooperate even when there is no clear dominant power.*

Arguably, *After Hegemony*'s greatest influence on disciplines other than international relations has been on international law. Following Keohane's analysis of how and why international regimes help cooperation between states to happen, international lawyers have been working on building a coherent framework to explain why and how international law helps states that are looking to cooperate.[2] Some international lawyers even consider international law a regime in its own right.[3] Others agree with Keohane that international law can affect state behavior even after the end of hegemony.*[4] *After*

*Hegemony* provided a useful framework for those working on the uses of international law in fields such as environmental law and trade law to discuss their ideas.

The book's influence beyond academia has been more indirect. Along with the work of other international relations scholars, Keohane's *After Hegemony* (and related publications) form a body of work that argues persuasively for the benefits of international regimes in fostering cooperation that profits the United States. The fact that political scientists such as Stephen D. Krasner,* Joseph S. Nye, Jr.,* and Anne-Marie Slaughter,* all important contributors to the discussion that the work provoked, have all held influential positions with different American administrations, suggests that the text has influenced American foreign policy—and international politics as a result.

## The Continuing Debate

The debate between neorealists* and neoliberals has been enhanced by the development of new theories of international relations, most notably constructivism,* with its emphasis on the socially constructed nature of international relations. In this debate among different theoretical traditions, international cooperation and regimes remain a key issue. The text is particularly useful, because it is the model of neoliberal thought in this field.

*After Hegemony* is still vital and current, thanks in no small part to the renewed relevance of realist* thought and its vision of states acting pragmatically* in the pursuit of their self-interest. This is seen in a number of areas:

- Neoclassical realism*—which believes that states act according to how power is distributed in the international system, and how that system is perceived
- Offensive realism*—according to which the international system provokes states to aggression

- Defensive realism*—according to which the international system causes states to concentrate on their security, with destabilizing effects.

Following the collapse of the Soviet Union* in 1991 and end of the Cold War,* realism was considered by many to be obsolete. Works such as the political scientist Francis Fukuyama's* *The End of History and the Last Man*[5] or the neoliberal scholar G. John Ikenberry's* *After Victory: Institutions, Strategic Restraint, and the Rebuilding of Order after Major Wars*[6] exemplified the widespread belief that economic liberalism* had displaced other ideologies and theories, due to its "defeat" of fascism* and communism* and the spread of democracy* and markets.* However, neoclassical realism, offensive realism, and defensive realism offered coherent theories that became increasingly popular after the 9/11* terrorist attacks of September 11, 2001 and the unilateral response of the administration of President George W. Bush.* Neoliberal and neorealist thought, then, found themselves in opposition again.

## NOTES

1   Robert O. Keohane, *After Hegemony: Cooperation and Discord in the World Political Economy* (Princeton: Princeton University Press, 1984), 6–7.

2   Anne-Marie Slaughter, "International Law and International Relations Theory: A Dual Agenda," *The American Journal of International Law* 87, no. 2 (1993): 205–39.

3   Nico Krisch, "International Law in Times of Hegemony: Unequal Power and the Shaping of the International Legal Order," *The European Journal of International Law* 16, no. 3 (2005): 369–408.

4   Colm Campbell, "'Wars on Terror' and Vicarious Hegemons: The UK, International Law, and the Northern Ireland Conflict," *International and Comparative Law Quarterly* 54, no. 2 (2005): 321–56; Slaughter, "International Law and International Relations," 205–39.

5   See Francis Fukuyama, *The End of History and the Last Man* (New York: Free Press, 1992).

6   See G. John Ikenberry, *After Victory: Institutions, Strategic Restraint, and the Rebuilding of Order after Major Wars* (Princeton: Princeton University

# WHERE NEXT?

## KEY POINTS

- *After Hegemony* looks like it will still be relevant in the future, given its prominent position in the teaching of international relations.*

- It is likely that neoliberal* scholars will continue to build on the ideas contained in the book as they develop their own work.

- *After Hegemony* is essential reading for people interested in learning about international relations.

### Potential

Robert O. Keohane's *After Hegemony: Cooperation and Discord in the World Political Economy* is an essential text on international relations students' reading lists around the world. This means it is very likely to continue to be an influential text in the field of international relations and even beyond this academic discipline, supported as it is by a growing body of work building on its key ideas. Since Keohane is still considered one of the most influential contemporary international relations scholars,[1] and neoliberalism* continues to be a popular theory of international relations,[2] it is also likely his ideas will continue to influence research.

Scholars of international relations who subscribe to neoliberal thought are likely to continue to be employed by Western governments, and will continue to influence the foreign policy of states that play a large role in shaping the international system.

Finally, Keohane remains an active scholar, writer and teacher.

> **❝** Keohane's thoughts on both the conditions under which states co-operate with each other and the role of institutions in facilitating co-operation have evolved from seeking to challenge the explanatory adequacy of the realist paradigm to a more nuanced accommodation with the insights of structural realism. Whether this constitutes progress or regress in the study of international organization remains a hotly debated issue, but there is no questioning the pivotal importance of Keohane's work in raising it. **❞**
>
> Martin Griffiths, *Fifty Key Thinkers in International Relations*

Since he has not altered the fundamentals of his approach to the study of international politics, he will continue to spread the ideas that underpin *After Hegemony*.

Neoliberal scholarship since the publication of *After Hegemony* has mostly been devoted to understanding better the ways in which international regimes* foster cooperation, with scholars focusing on specific issues such as security, the environment, and human rights.[3] These academics have also been the main driving force behind the development of the study of global governance,* the processes by which problems of international security and financial stability, and so on, might be solved. This is an area that has become very popular since 9/11—the terrorist attacks of September 11, 2001. This means the core ideas of *After Hegemony* will continue to be applied in the future—if not significantly developed.

### Future Directions

Current supporters of neoliberalism in general, and Keohane's *After Hegemony* in particular, still support and spread its key notions.

Neoliberals believe that international regimes promote cooperation. Furthermore, they believe that international regimes do not require a hegemon* to exist and operate, and that cooperation is not as uncommon as the rival school of thought, neorealism,* suggests. The influence of Keohane's *After Hegemony* is therefore essential to understanding the intellectual foundations of authors who will continue to develop neoliberal theory. New authors working in the neoliberal tradition appear to be faithful to *After Hegemony*.[4] The text has not been reinterpreted to date, and is unlikely to be so in the near future.

As for neoliberalism itself, it remains one of the three most popular approaches to the study of international politics. Along with neorealism and constructivism,* it is one of the theoretical approaches most international relations scholars identify with, one of the theoretical approaches most commonly taught in class, and one of the most published.[5] The influence of neoliberalism among students, scholars and practitioners of international relations has not decreased since the publication of *After Hegemony*. If anything, it has actually increased.

## Summary

*After Hegemony* is one of the key texts of neoliberalism in international relations. Since neoliberalism continues to be one of the most influential theoretical approaches for those engaged in the study and the practice of international politics alike, no scholar of international relations can properly understand this field without knowing the arguments the book makes.

*After Hegemony* is second to none in laying out the key principles of neoliberalism:

- International regimes do not need a hegemon to operate.
- International regimes foster cooperation.
- Cooperation is not as uncommon as other theories, especially

neorealism, suggest.

Keohane, a fellow of the American Academy of Arts and Sciences and a member of the US National Academy of Sciences, the American Academy of Political and Social Science and the American Philosophical Society,[6] is one of the key figures of contemporary international relations. After the political scientist Alexander Wendt,[*7] he is considered the most influential scholar of international relations over the past 20 years.

*After Hegemony* is Keohane's best-known text. It is original and impactful in laying out the key principles of neoliberal thought coherently, logically and clearly. In addition, it is a key text promoting the status of neoliberalism as a valid alternative to the neorealist thought that characterized the theory of international relations in a world shaped by the Cold War.*

## NOTES

1   Daniel Maliniak et al., *TRIP Around the World: Teaching, Research, and Policy Views of International Relations Faculty in 20 Countries* (Williamsburg, VA: Teaching, Research, and International Policy (TRIP) Project, 2012), 49.

2   Maliniak et al., *TRIP Around the World*, 27.

3   See Google Scholar, JSTOR and other academic search databases.

4   See Google Scholar, JSTOR and other academic search databases.

5   Maliniak et al., *TRIP Around the World*, 12, 27, 47.

6   "Curriculum Vitae," Princeton University, accessed January 4, 2015, http://www.princeton.edu/~rkeohane/cv.pdf.

7   Maliniak et al., *TRIP Around the World*, 49.

# GLOSSARY

# GLOSSARY OF TERMS

**Absolute gain**: a means by which international actors—states and organizations—decide what is in their interests, weighing up the total effects of a decision and then acting accordingly.

**Anarchy:** a situation of leaderlessness. Sovereign states exist in an anarchic world because they have no authority compelling them one way or another.

**Bipolar**: a distribution of power in the international system; a bipolar system has power concentrated in two states, whereas a unipolar system has only one pole (also known as hegemony); a multipolar system has power concentrated among three or more states.

**Bounded rationality:** a social science concept that says that levels of rationality are constrained by limits on the amount of available information, on the capacity of the human mind to process information, and on the amount of time it takes to make a decision.

**Bretton Woods:** a system of monetary and financial management established in 1945. The system collapsed in 1971.

**Cold War (1947–91):** a period of tension between the US and the Soviet Union. While the two blocs never engaged in direct military conflict, they engaged in covert and proxy wars and espionage against one another.

**Communism:** a political ideology that relies on the state ownership of the means of production, the collectivization of labor, and the abolition of social class.

**Conservative:** a person, party or other institution holding values considered to be traditional and less open to change.

**Constructivism:** one of the three most widely applied theoretical approaches to the study of international relations. Its key tenet is the notion that international relations are socially constructed. Therefore, interactions among actors (typically states) are the result of the ways in which these actors understand both themselves and others.

**Counterterrorism:** the activities, especially military and political, undertaken in order to combat terrorism.

**Defensive realism:** a theory of international relations that builds on neorealism. It maintains that the structure of the international system makes states focus on their own security, thus increasing the likelihood of conflict.

**Democracy:** a system of government in which the ruler or rulers of a state are elected by the people, who can also participate in government through other channels such as referenda.

**Empiricism:** the belief that knowledge is derived from the study of observable evidence.

**Eastern bloc:** One of the two main groups of states during the Cold War* the other being the Western bloc. The Eastern or Soviet bloc comprised the Soviet Union, Eastern Europe, and other countries with a similar economic and political system in Africa, the Americas, and the Asia Pacific.

**European Union:** a political and economic family of institutions that govern the legal, economic, and political union of 28 European States.

**Fascism:** a system of government typically based on nationalism and racism and marked by centralization of authority under a dictator, total control of the economy and society, and the prevention of any opposition through acts of terror and censorship.

**Free rider:** a person, state or other actor who receives the benefits of a public good without contributing to its production.

**Functionalism:** a theory of international relations that argues that the needs and common interests of state and non-state actors drive integration.

**Global governance:** the process of interaction among state and non-state actors to solve transnational problems and to prevent those problems from arising in the future.

**Grand theory:** an abstract theory where analytical and formal organization of concepts happens ahead of using observable evidence.

**Hegemon:** a social group, especially a political state, that has achieved a position of dominance over all the other states.

**Hegemony:** leadership or dominance, especially by one country or social group over others. When a state achieves dominance over all other states they are considered a hegemon.

**Idealism:** a theoretical approach to international relations according to which international politics can be defined by peace and cooperation if states seek to achieve relative rather than absolute gains.

**International regime:** a set of principles, norms, and decision-making procedures agreed by a number of actors (usually states) who explicitly or implicitly agree to abide by them.

**International relations:** an academic discipline focusing on the study of relations among states and other actors active at the international level.

**Liberalism:** a theory that argues that international politics can be defined by peace and cooperation if states seek to achieve absolute rather than relative gains.

**Market:** a physical or nominal institution that allows buyers and sellers of goods and services to interact—directly or through intermediaries—and exchange products for other products or, more commonly, money.

**Multilateralism:** a situation in which multiple states, organizations or other actors work together to achieve a common goal.

**Multipolar:** a distribution of power in the international system; a bipolar system has power concentrated in two states, whereas a unipolar system has only one pole (also known as hegemony); a multipolar system has power concentrated among three or more states.

**Neoclassical realism:** a theory of international relations that mixes elements of realism and neorealism, according to which state behavior is decided by the structure of the international system, perceptions of this structure, and domestic developments.

**Neoliberal:** a person who adheres to the theory of neoliberalism.

**Neoliberalism:** a theory of international relations according to which states should be concerned with absolute rather than relative gains. Focusing on absolute gains, neoliberalism allows for cooperative behavior among states to take place.

**Neorealism:** a theory of international relations according to which state behavior is the result of the structure of the international system and the constraints it poses on its actors.

**Neorealist:** a person who adheres to the theory of neorealism.

**9/11:** on September 11, 2001, two commercial airliners hijacked by Islamic fundamentalist terrorists were flown into the World Trade Center, New York, killing approximately 3,000 people. A third hijacked airliner was crashed into the Pentagon and a fourth went down in a field in Pennsylvania.

**Nuclear nonproliferation:** the measures taken to prevent the spread of nuclear weapons.

**Offensive realism:** a theory of international relations that, building on neorealism, maintains that the structure of the international systems makes states behave aggressively, thus increasing the likelihood of conflict.

**Oil crises:** two crises in 1973 and 1979 resulted from a sudden increase in the price of oil due to political developments in the Middle East. The crises slowed down economic growth and pushed up inflation in the West.

**Positivism:** a perspective in the philosophy of science. It holds that information must be obtained by sensory experience (what is seen and heard in the real world). Laws are derived from these observations and tested through experimentation.

**Pragmatism:** an approach to beliefs or actions that values them in terms of outcomes.

**Rational choice:** a social science-based theory that is based on the idea that human behavior is driven by logical decisions taken to maximize one's own interest.

**Realism:** a theory of international relations arguing that international politics are defined by competition among states seeking to achieve relative gains.

**Relative gain:** a means by which international actors determine their interests in respect of power balances, while disregarding other key factors, like economics.

**Sovereignty:** the supreme authority or rule of a governing body over a defined territory, usually a state.

**Soviet Union:** a federal communist republic officially known as the Union of Soviet Socialist Republics (USSR) that existed between 1922 and 1991.

**Superpower:** a very powerful and influential nation, this is a term often used to refer both to the United States and the Soviet Union during the Cold War, when they were the two most powerful nations in the world.

**Unipolar:** a distribution of power in the international system; a bipolar system has power concentrated in two states, whereas a unipolar system has only one pole (also known as hegemony); a multipolar system has power concentrated among three or more states.

**United Nations:** an intergovernmental organization established in 1945 to promote and support peace and cooperation among states. Its remit has expanded over the decades, and now covers issues such as

climate change, sustainable development, human security and terrorism.

**United Nations General Assembly:** the main deliberative, policymaking and representative organ of the United Nations, which makes decisions on important matters—including peace and security.

**Vietnam War (1955–75):** a Cold War conflict between the United States and the communist forces of North Vietnam. In 1973, the US signed a peace treaty and withdrew its forces from South Vietnam, which collapsed two years later.

**War on Terror:** a military campaign initiated by the administration of President George W. Bush of the United States following the 9/11 terrorist attacks, largely conducted in the Middle East.

**Western bloc:** one of the two main groups of states during the Cold War, the other being the Eastern or Soviet bloc. The Western bloc comprised the United States, Western Europe, and other countries with similar economic and social systems.

**World War II (1939–45):** a six-year military conflict between the Axis forces—Germany, Italy and Japan—and the Allied forces—the Soviet Union, the United Kingdom and the United States. It was the deadliest war in history, with over 60 million civilian and military casualties.

# PEOPLE MENTIONED IN THE TEXT

**Robert J. Art (b. 1942)** is a political scientist, currently the Christian A. Herter Professor of International Relations at Brandeis University.

**Robert Axelrod (b. 1943)** is professor of political science and public policy at the University of Michigan.

**George W. Bush (b. 1946)** was the 43rd president of the United States, from 2001 to 2009.

**Jeffrey Checkel (b. 1959)** is professor of international studies and Simons Chair in international law and human security at Simon Fraser University. He is a leading figure of the constructivist school of international relations.

**Francis Fukuyama (b. 1952)** is the Olivier Nomellini Senior Fellow at Stanford University. He is one of the most prominent contemporary political scientists, having argued in his book *The End of History and the Last Man* that the evolution of humanity ends with liberal democracy and free market capitalism.

**Robert Gilpin (b. 1930)** is one of the central figures in the development of international political economy as a sub-field of international relations. He is also considered one of the main realists in contemporary international relations.

**Judith Goldstein (b. 1952)** is a political scientist, currently the Janet M. Peck Professor at Stanford University.

**Joseph M. Grieco (b. 1953)** is a political scientist, currently professor at Duke University.

**Ernst B. Haas (1924–2003)** was an American political scientist of German origin. He is considered the founder of neofunctionalism in international relations. Taking the example of the European Union, this theory explains that states create the conditions for regional integration, which is then developed through the work of other, non-state actors.

**Stanley Hoffmann (b. 1928)** is a political scientist, named the first Paul and Catherine Buttenwieser University Professor at Harvard University. Hoffmann developed a theory of regional integration labeled "intergovernmentalism", which suggests that the speed of integration among states depends on the actions of national governments.

**G. John Ikenberry (b. 1954)** is the Albert G. Milbank Professor of Politics and International Affairs at Princeton University. He is one of the most prominent contemporary neoliberal scholars, as well as one of the foremost analysts of the liberal principles of American foreign policy.

**Charles P. Kindleberger (1910–2003)** was one of the earliest political economists. He also worked for the US government on several occasions, holding positions with the Federal Reserve and the Department of State, among others.

**Stephen D. Krasner (b. 1942)** is an American international relations scholar who served as a US Department of State official during the presidency of George W. Bush. He wrote the most popular definition of international regimes, which he describes as "sets of implicit or explicit principles, norms, rules, and decision making procedures around which actors' expectations converge in a given area of international relations."

**Charles Lipson (b. 1948)** is a political scientist who is currently the Peter B. Ritzma Professor in Political Science at Chicago University.

**Lisa Martin (b. 1961)** is a political scientist, who is currently professor at the University of Wisconsin-Madison.

**John Mearsheimer (b. 1947)** is a political scientist, currently the R. Wendell Harrison Distinguished Service Professor at Chicago University and a neorealist. He is the pioneer of "offensive realism," a contemporary reformulation of neorealism.

**Philip Noel-Baker (1889–1982)** was a British politician, diplomat, and academic who received the Nobel Peace Prize in 1959. He was involved in the creation of the League of Nations, campaigned for nuclear disarmament for decades, and was one of the first professors of international relations in the world, having been appointed the Montague Burton Professor at the London School of Economics in 1924.

**Joseph S. Nye, Jr. (b. 1937)** is an American political scientist who served as an intelligence and foreign policy official during the presidency of Bill Clinton. Along with Keohane, he is considered the co-founder of neoliberalism in international relations. Nye is also credited with having coined the terms "soft power" and "smart power."

**Kenneth Oye (b. 1949)** is a professor of political science and engineering at the Massachusetts Institute of Technology (MIT).

**Ronald Reagan (1911–2004)** was the 40th president of the United States. He was in office from 1981 to 1989.

**John Ruggie (b. 1944)** is the Berthold Beitz Professor in Human Rights and International Affairs at Harvard University. He is considered

one of the leading international relations scholars of the late twentieth and early twenty-first centuries, having introduced the concepts of "embedded liberalism" and "international regimes" to the field.

**Randall Schweller** is a professor of political science at Ohio State University.

**Beth Simmons (b. 1958)** is a political scientist who is the Clarence Dillon Professor at Harvard University.

**Anne-Marie Slaughter (b. 1958)** is a political scientist and international lawyer who was a director of policy planning at the US Department of State during the presidency of Barack Obama. Currently she is president and CEO of the New American Foundation.

**Duncan Snidal** is a professor of international relations at Nuffield College, University of Oxford.

**Stephen Walt (b. 1955)** is a professor of political science at Harvard University.

**Kenneth Waltz (1924–2013)** was a key international relations scholar, and the founder of neorealism with his book *Theory of International Politics*, published in 1979. He was also the author of *Man, the State, and War*, which discussed three levels of analysis applicable to international politics: individual, state, and international system.

**Alexander Wendt (b. 1958)** is currently the Mershon Professor of International Security and professor of political science at Ohio State University, and is considered one of the founding fathers of the constructivist school of international relations. In a recent TRIP

survey of International Relations scholars he was named as the most influential scholar in the field over the past 20 years.

**William Wohlforth (b. 1959)** is a political scientist, currently the Daniel Webster Professor of Government at Dartmouth College.

**Oran R. Young (b. 1941)** is an American international relations scholar and the founding chair of the Committee on the Human Dimensions of Global Change at the American National Academy of Sciences. He is best known for his work on governance in international politics, especially environmental governance.

**Alfred Zimmern (1879–1957)** was a British political scientist. He was one of the first professors of international relations, having been appointed the Montague Burton Professor at the University of Oxford in 1930. Zimmern co-founded one of the oldest international relations think tanks—the Royal Institute of International Affairs, now known as Chatham House.

# WORKS CITED

# WORKS CITED

Andreatta, Filippo and Mathias Koenig-Archibugi. "Which Synthesis? Strategies of Theoretical Integration and the Neorealist-Neoliberal Debate." *International Political Science Review* 31, no. 2 (2010): 207–27.

Boas, Taylor C., and Jordan Gans-Morse. "Neoliberalism: From New Liberal Philosophy to Anti-Liberal Slogan." *Studies in Comparative International Development* 44, no. 2 (2009): 137–61.

Campbell, Colm. " Wars on Terror' and Vicarious Hegemons: The UK, International Law, and the Northern Ireland Conflict." *International and Comparative Law Quarterly* 54, no. 2 (2005): 321–56

Checkel, Jeffrey T. "The Constructive Turn in International Relations Theory." *World Politics* 50, no. 2 (1998): 324–48.

Cohen, Benjamin, J., et al. *International Organization* 36, no. 2 (1982): 185–510.

Colgan, Jeff, Robert O. Keohane, and Thijs Van de Graaf. "Punctuated Equilibrium in the Energy Regime Complex." *The Review of International Organizations* 7, no. 2 (2012): 117–43.

Fukuyama, Francis. *The End of History and the Last Man*. New York: Free Press, 1992.

Google Scholar. "Kenneth Waltz." Accessed May 19, 2015. https://scholar.google.com/scholar?cluster=7694130487730532041&hl=en&as_sdt=0,9

Google Scholar. "Robert Keohane, *After Hegemony*." Accessed May 13, 2015. https://scholar.google.com/scholar?cites=560052273688874574&as_sdt=20005&sciodt=0,9&hl=en.

Goldstein, Judith L., et al., eds. *Legalization and World Politics*. Cambridge: MIT Press, 2001.

Haas, Ernst B. *The Uniting of Europe: Political, Social, and Economic Forces, 1950–1957*. Stanford: Stanford University Press, 1958.

Haggard, Stephan. "Book Review: After Hegemony: Cooperation and Discord in the World Political Economy." *Worldview Magazine* 28, no. 4 (1985): 25–6.

Harvard Magazine. "Harvard Graduate School Honors Daniel Aaron, Nancy Hopkins and Others," May 23, 2012. Accessed March 31, 2015. http://harvardmagazine.com/2012/05/harvard-graduate-school-centennial-medalists-2012.

Ikenberry, G. John. *After Victory: Institutions, Strategic Restraint, and the Rebuilding of Order after Major Wars*. Princeton: Princeton University Press, 2001.

Keohane, Robert O. *After Hegemony: Cooperation and Discord in the World Political Economy*. Princeton: Princeton University Press, 1984.

———. "Hegemony and After: What Can Be Said about the Future of American Leadership?" *Foreign Affairs* 1, no. 4 (2012): 1–5.

———. "Institutional Theory and the Realist Challenge After the Cold War." In *Neorealism and Neoliberalism: The Contemporary Debate*, edited by David A. Baldwin, 269–300. New York: Columbia University Press, 1993.

———. "International Institutions: Two Approaches." *International Studies Quarterly* 32, no. 4 (1988): 379–96.

———. *Power and Governance in a Partially Globalized World*. Abingdon: Routledge, 2002.

———. "Realism, Neorealism and the Study of World Politics." In *Neorealism and Its Critics*, edited by Robert O. Keohane, 1–26. New York: Columbia University Press, 1986.

———. "Reciprocity in International Relations." *International Organization* 40, no. 1 (1986): 1–27.

———. "The Demand for International Regimes." *International Organization* 26, no. 2 (1982): 325–55.

Keohane, Robert O. and Joseph S. Nye. *Power and Interdependence: World Politics in Transition*. Boston: Little, Brown: 1977.

———. "Two Cheers for Multilateralism." *Foreign Policy* 60, no. 1 (1985): 148–67.

Keohane, Robert O. and Kal Raustiala. "Towards a Post-Kyoto Climate Change Architecture: A Political Analysis." In *Post-Kyoto International Climate Policy: Implementing Architectures for Agreement*, edited by Joseph E. Aldy and Robert N. Stavins, 372–400. Cambridge: Cambridge University Press, 2009.

Keohane, Robert O., and David G. Victor. "The Regime Complex for Climate Change." *Perspectives on Politics* 9, no. 1 (2011): 7–24.

Krasner, Stephen D. "Structural Causes and Regime Consequences: Regimes as Intervening Variables." *International Organization* 36, no. 2 (1982): 185–205.

Krisch, Nico. "International Law in Times of Hegemony: Unequal Power and the Shaping of the International Legal Order." *The European Journal of International Law* 16, no. 3 (2005): 369–408.

Lipson, Charles. "Why Are Some International Agreements Informal?" *International Organization* 45, no. 4 (1991): 495–538.

Maliniak, Daniel, Susan Peterson, and Michael J. Tierney. *TRIP Around the World: Teaching, Research, and Policy Views of International Relations Faculty in 20 Countries*. Williamsburg, VA: Teaching, Research, and International Policy (TRIP) Project, 2012.

Martin, Lisa L. "Interests, Power, and Multilateralism." *International Organization* 45, no. 4 (1992): 765–92.

Oye, Kenneth, and James Maxwell. "Self-interest and Environmental Management." *Journal of Theoretical Politics* 6, no. 4 (1994): 593–624.

Powell, Robert. "Anarchy in International Relations Theory: The Neorealist-Neoliberal Debate." *International Organization* 48, no. 2 (1994): 313–44.

Princeton University. "Curriculum Vitae." Accessed January 4, 2015. http://www.princeton.edu/~rkeohane/cv.pdf.

Princeton University Press. "After Hegemony: Cooperation and Discord in the World Political Economy." Accessed January 4, 2015. http://press.princeton.edu/titles/1322.html.

Slaughter, Anne-Marie. "International Law and International Relations Theory: A Dual Agenda." *The American Journal of International Law* 87, no. 2 (1993): 205–39.

Snidal, Duncan. "Relative Gains and the Pattern of International Cooperation." *American Political Science Review* 85, no. 3 (1991): 701–26.

Theory Talks. "Theory Talk #9: Robert Keohane," May 29, 2008. Accessed May 26, 2013. http://www.theory-talks.org/2008/05/theory-talk-9.html.

University of California, Berkeley. "Conversations with History: Robert O. Keohane," March 7, 2008. Accessed May 26, 2013. http://www.youtube.com/watch?v=5foxGFXNl-s.

Waltz, Kenneth. *Theory of International Politics*. New York: McGraw Hill, 1979.

# THE MACAT LIBRARY
# BY DISCIPLINE

**AFRICANA STUDIES**

Chinua Achebe's *An Image of Africa: Racism in Conrad's Heart of Darkness*
W. E. B. Du Bois's *The Souls of Black Folk*
Zora Neale Huston's *Characteristics of Negro Expression*
Martin Luther King Jr's *Why We Can't Wait*
Toni Morrison's *Playing in the Dark: Whiteness in the American Literary Imagination*

**ANTHROPOLOGY**

Arjun Appadurai's *Modernity at Large: Cultural Dimensions of Globalisation*
Philippe Ariès's *Centuries of Childhood*
Franz Boas's *Race, Language and Culture*
Kim Chan & Renée Mauborgne's *Blue Ocean Strategy*
Jared Diamond's *Guns, Germs & Steel: the Fate of Human Societies*
Jared Diamond's *Collapse: How Societies Choose to Fail or Survive*
E. E. Evans-Pritchard's *Witchcraft, Oracles and Magic Among the Azande*
James Ferguson's *The Anti-Politics Machine*
Clifford Geertz's *The Interpretation of Cultures*
David Graeber's *Debt: the First 5000 Years*
Karen Ho's *Liquidated: An Ethnography of Wall Street*
Geert Hofstede's *Culture's Consequences: Comparing Values, Behaviors, Institutes and Organizations across Nations*
Claude Lévi-Strauss's *Structural Anthropology*
Jay Macleod's *Ain't No Makin' It: Aspirations and Attainment in a Low-Income Neighborhood*
Saba Mahmood's *The Politics of Piety: The Islamic Revival and the Feminist Subject*
Marcel Mauss's *The Gift*

**BUSINESS**

Jean Lave & Etienne Wenger's *Situated Learning*
Theodore Levitt's *Marketing Myopia*
Burton G. Malkiel's *A Random Walk Down Wall Street*
Douglas McGregor's *The Human Side of Enterprise*
Michael Porter's *Competitive Strategy: Creating and Sustaining Superior Performance*
John Kotter's *Leading Change*
C. K. Prahalad & Gary Hamel's *The Core Competence of the Corporation*

**CRIMINOLOGY**

Michelle Alexander's *The New Jim Crow: Mass Incarceration in the Age of Colorblindness*
Michael R. Gottfredson & Travis Hirschi's *A General Theory of Crime*
Richard Herrnstein & Charles A. Murray's *The Bell Curve: Intelligence and Class Structure in American Life*
Elizabeth Loftus's *Eyewitness Testimony*
Jay Macleod's *Ain't No Makin' It: Aspirations and Attainment in a Low-Income Neighborhood*
Philip Zimbardo's *The Lucifer Effect*

**ECONOMICS**

Janet Abu-Lughod's *Before European Hegemony*
Ha-Joon Chang's *Kicking Away the Ladder*
David Brion Davis's *The Problem of Slavery in the Age of Revolution*
Milton Friedman's *The Role of Monetary Policy*
Milton Friedman's *Capitalism and Freedom*
David Graeber's *Debt: the First 5000 Years*
Friedrich Hayek's *The Road to Serfdom*
Karen Ho's *Liquidated: An Ethnography of Wall Street*

John Maynard Keynes's *The General Theory of Employment, Interest and Money*
Charles P. Kindleberger's *Manias, Panics and Crashes*
Robert Lucas's *Why Doesn't Capital Flow from Rich to Poor Countries?*
Burton G. Malkiel's *A Random Walk Down Wall Street*
Thomas Robert Malthus's *An Essay on the Principle of Population*
Karl Marx's *Capital*
Thomas Piketty's *Capital in the Twenty-First Century*
Amartya Sen's *Development as Freedom*
Adam Smith's *The Wealth of Nations*
Nassim Nicholas Taleb's *The Black Swan: The Impact of the Highly Improbable*
Amos Tversky's & Daniel Kahneman's *Judgment under Uncertainty: Heuristics and Biases*
Mahbub Ul Haq's *Reflections on Human Development*
Max Weber's *The Protestant Ethic and the Spirit of Capitalism*

## FEMINISM AND GENDER STUDIES

Judith Butler's *Gender Trouble*
Simone De Beauvoir's *The Second Sex*
Michel Foucault's *History of Sexuality*
Betty Friedan's *The Feminine Mystique*
Saba Mahmood's *The Politics of Piety: The Islamic Revival and the Feminist Subject*
Joan Wallach Scott's *Gender and the Politics of History*
Mary Wollstonecraft's *A Vindication of the Rights of Woman*
Virginia Woolf's *A Room of One's Own*

## GEOGRAPHY

The Brundtland Report's *Our Common Future*
Rachel Carson's *Silent Spring*
Charles Darwin's *On the Origin of Species*
James Ferguson's *The Anti-Politics Machine*
Jane Jacobs's *The Death and Life of Great American Cities*
James Lovelock's *Gaia: A New Look at Life on Earth*
Amartya Sen's *Development as Freedom*
Mathis Wackernagel & William Rees's *Our Ecological Footprint*

## HISTORY

Janet Abu-Lughod's *Before European Hegemony*
Benedict Anderson's *Imagined Communities*
Bernard Bailyn's *The Ideological Origins of the American Revolution*
Hanna Batatu's *The Old Social Classes And The Revolutionary Movements Of Iraq*
Christopher Browning's *Ordinary Men: Reserve Police Batallion 101 and the Final Solution in Poland*
Edmund Burke's *Reflections on the Revolution in France*
William Cronon's *Nature's Metropolis: Chicago And The Great West*
Alfred W. Crosby's *The Columbian Exchange*
Hamid Dabashi's *Iran: A People Interrupted*
David Brion Davis's *The Problem of Slavery in the Age of Revolution*
Nathalie Zemon Davis's *The Return of Martin Guerre*
Jared Diamond's *Guns, Germs & Steel: the Fate of Human Societies*
Frank Dikotter's *Mao's Great Famine*
John W Dower's *War Without Mercy: Race And Power In The Pacific War*
W. E. B. Du Bois's *The Souls of Black Folk*
Richard J. Evans's *In Defence of History*
Lucien Febvre's *The Problem of Unbelief in the 16th Century*
Sheila Fitzpatrick's *Everyday Stalinism*

# The Macat Library By Discipline

Eric Foner's *Reconstruction: America's Unfinished Revolution, 1863-1877*
Michel Foucault's *Discipline and Punish*
Michel Foucault's *History of Sexuality*
Francis Fukuyama's *The End of History and the Last Man*
John Lewis Gaddis's *We Now Know: Rethinking Cold War History*
Ernest Gellner's *Nations and Nationalism*
Eugene Genovese's *Roll, Jordan, Roll: The World the Slaves Made*
Carlo Ginzburg's *The Night Battles*
Daniel Goldhagen's *Hitler's Willing Executioners*
Jack Goldstone's *Revolution and Rebellion in the Early Modern World*
Antonio Gramsci's *The Prison Notebooks*
Alexander Hamilton, John Jay & James Madison's *The Federalist Papers*
Christopher Hill's *The World Turned Upside Down*
Carole Hillenbrand's *The Crusades: Islamic Perspectives*
Thomas Hobbes's *Leviathan*
Eric Hobsbawm's *The Age Of Revolution*
John A. Hobson's *Imperialism: A Study*
Albert Hourani's *History of the Arab Peoples*
Samuel P. Huntington's *The Clash of Civilizations and the Remaking of World Order*
C. L. R. James's *The Black Jacobins*
Tony Judt's *Postwar: A History of Europe Since 1945*
Ernst Kantorowicz's *The King's Two Bodies: A Study in Medieval Political Theology*
Paul Kennedy's *The Rise and Fall of the Great Powers*
Ian Kershaw's *The "Hitler Myth": Image and Reality in the Third Reich*
John Maynard Keynes's *The General Theory of Employment, Interest and Money*
Charles P. Kindleberger's *Manias, Panics and Crashes*
Martin Luther King Jr's *Why We Can't Wait*
Henry Kissinger's *World Order: Reflections on the Character of Nations and the Course of History*
Thomas Kuhn's *The Structure of Scientific Revolutions*
Georges Lefebvre's *The Coming of the French Revolution*
John Locke's *Two Treatises of Government*
Niccolò Machiavelli's *The Prince*
Thomas Robert Malthus's *An Essay on the Principle of Population*
Mahmood Mamdani's *Citizen and Subject: Contemporary Africa And The Legacy Of Late Colonialism*
Karl Marx's *Capital*
Stanley Milgram's *Obedience to Authority*
John Stuart Mill's *On Liberty*
Thomas Paine's *Common Sense*
Thomas Paine's *Rights of Man*
Geoffrey Parker's *Global Crisis: War, Climate Change and Catastrophe in the Seventeenth Century*
Jonathan Riley-Smith's *The First Crusade and the Idea of Crusading*
Jean-Jacques Rousseau's *The Social Contract*
Joan Wallach Scott's *Gender and the Politics of History*
Theda Skocpol's *States and Social Revolutions*
Adam Smith's *The Wealth of Nations*
Timothy Snyder's *Bloodlands: Europe Between Hitler and Stalin*
Sun Tzu's *The Art of War*
Keith Thomas's *Religion and the Decline of Magic*
Thucydides's *The History of the Peloponnesian War*
Frederick Jackson Turner's *The Significance of the Frontier in American History*
Odd Arne Westad's *The Global Cold War: Third World Interventions And The Making Of Our Times*

## LITERATURE

Chinua Achebe's *An Image of Africa: Racism in Conrad's Heart of Darkness*
Roland Barthes's *Mythologies*
Homi K. Bhabha's *The Location of Culture*
Judith Butler's *Gender Trouble*
Simone De Beauvoir's *The Second Sex*
Ferdinand De Saussure's *Course in General Linguistics*
T. S. Eliot's *The Sacred Wood: Essays on Poetry and Criticism*
Zora Neale Huston's *Characteristics of Negro Expression*
Toni Morrison's *Playing in the Dark: Whiteness in the American Literary Imagination*
Edward Said's *Orientalism*
Gayatri Chakravorty Spivak's *Can the Subaltern Speak?*
Mary Wollstonecraft's *A Vindication of the Rights of Women*
Virginia Woolf's *A Room of One's Own*

## PHILOSOPHY

Elizabeth Anscombe's *Modern Moral Philosophy*
Hannah Arendt's *The Human Condition*
Aristotle's *Metaphysics*
Aristotle's *Nicomachean Ethics*
Edmund Gettier's *Is Justified True Belief Knowledge?*
Georg Wilhelm Friedrich Hegel's *Phenomenology of Spirit*
David Hume's *Dialogues Concerning Natural Religion*
David Hume's *The Enquiry for Human Understanding*
Immanuel Kant's *Religion within the Boundaries of Mere Reason*
Immanuel Kant's *Critique of Pure Reason*
Søren Kierkegaard's *The Sickness Unto Death*
Søren Kierkegaard's *Fear and Trembling*
C. S. Lewis's *The Abolition of Man*
Alasdair MacIntyre's *After Virtue*
Marcus Aurelius's *Meditations*
Friedrich Nietzsche's *On the Genealogy of Morality*
Friedrich Nietzsche's *Beyond Good and Evil*
Plato's *Republic*
Plato's *Symposium*
Jean-Jacques Rousseau's *The Social Contract*
Gilbert Ryle's *The Concept of Mind*
Baruch Spinoza's *Ethics*
Sun Tzu's *The Art of War*
Ludwig Wittgenstein's *Philosophical Investigations*

## POLITICS

Benedict Anderson's *Imagined Communities*
Aristotle's *Politics*
Bernard Bailyn's *The Ideological Origins of the American Revolution*
Edmund Burke's *Reflections on the Revolution in France*
John C. Calhoun's *A Disquisition on Government*
Ha-Joon Chang's *Kicking Away the Ladder*
Hamid Dabashi's *Iran: A People Interrupted*
Hamid Dabashi's *Theology of Discontent: The Ideological Foundation of the Islamic Revolution in Iran*
Robert Dahl's *Democracy and its Critics*
Robert Dahl's *Who Governs?*
David Brion Davis's *The Problem of Slavery in the Age of Revolution*

The Macat Library By Discipline

Alexis De Tocqueville's *Democracy in America*
James Ferguson's *The Anti-Politics Machine*
Frank Dikotter's *Mao's Great Famine*
Sheila Fitzpatrick's *Everyday Stalinism*
Eric Foner's *Reconstruction: America's Unfinished Revolution, 1863-1877*
Milton Friedman's *Capitalism and Freedom*
Francis Fukuyama's *The End of History and the Last Man*
John Lewis Gaddis's *We Now Know: Rethinking Cold War History*
Ernest Gellner's *Nations and Nationalism*
David Graeber's *Debt: the First 5000 Years*
Antonio Gramsci's *The Prison Notebooks*
Alexander Hamilton, John Jay & James Madison's *The Federalist Papers*
Friedrich Hayek's *The Road to Serfdom*
Christopher Hill's *The World Turned Upside Down*
Thomas Hobbes's *Leviathan*
John A. Hobson's *Imperialism: A Study*
Samuel P. Huntington's *The Clash of Civilizations and the Remaking of World Order*
Tony Judt's *Postwar: A History of Europe Since 1945*
David C. Kang's *China Rising: Peace, Power and Order in East Asia*
Paul Kennedy's *The Rise and Fall of Great Powers*
Robert Keohane's *After Hegemony*
Martin Luther King Jr.'s *Why We Can't Wait*
Henry Kissinger's *World Order: Reflections on the Character of Nations and the Course of History*
John Locke's *Two Treatises of Government*
Niccolò Machiavelli's *The Prince*
Thomas Robert Malthus's *An Essay on the Principle of Population*
Mahmood Mamdani's *Citizen and Subject: Contemporary Africa And The Legacy Of Late Colonialism*
Karl Marx's *Capital*
John Stuart Mill's *On Liberty*
John Stuart Mill's *Utilitarianism*
Hans Morgenthau's *Politics Among Nations*
Thomas Paine's *Common Sense*
Thomas Paine's *Rights of Man*
Thomas Piketty's *Capital in the Twenty-First Century*
Robert D. Putman's *Bowling Alone*
John Rawls's *Theory of Justice*
Jean-Jacques Rousseau's *The Social Contract*
Theda Skocpol's *States and Social Revolutions*
Adam Smith's *The Wealth of Nations*
Sun Tzu's *The Art of War*
Henry David Thoreau's *Civil Disobedience*
Thucydides's *The History of the Peloponnesian War*
Kenneth Waltz's *Theory of International Politics*
Max Weber's *Politics as a Vocation*
Odd Arne Westad's *The Global Cold War: Third World Interventions And The Making Of Our Times*

**POSTCOLONIAL STUDIES**

Roland Barthes's *Mythologies*
Frantz Fanon's *Black Skin, White Masks*
Homi K. Bhabha's *The Location of Culture*
Gustavo Gutiérrez's *A Theology of Liberation*
Edward Said's *Orientalism*
Gayatri Chakravorty Spivak's *Can the Subaltern Speak?*

## PSYCHOLOGY

Gordon Allport's *The Nature of Prejudice*
Alan Baddeley & Graham Hitch's *Aggression: A Social Learning Analysis*
Albert Bandura's *Aggression: A Social Learning Analysis*
Leon Festinger's *A Theory of Cognitive Dissonance*
Sigmund Freud's *The Interpretation of Dreams*
Betty Friedan's *The Feminine Mystique*
Michael R. Gottfredson & Travis Hirschi's *A General Theory of Crime*
Eric Hoffer's *The True Believer: Thoughts on the Nature of Mass Movements*
William James's *Principles of Psychology*
Elizabeth Loftus's *Eyewitness Testimony*
A. H. Maslow's *A Theory of Human Motivation*
Stanley Milgram's *Obedience to Authority*
Steven Pinker's *The Better Angels of Our Nature*
Oliver Sacks's *The Man Who Mistook His Wife For a Hat*
Richard Thaler & Cass Sunstein's *Nudge: Improving Decisions About Health, Wealth and Happiness*
Amos Tversky's *Judgment under Uncertainty: Heuristics and Biases*
Philip Zimbardo's *The Lucifer Effect*

## SCIENCE

Rachel Carson's *Silent Spring*
William Cronon's *Nature's Metropolis: Chicago And The Great West*
Alfred W. Crosby's *The Columbian Exchange*
Charles Darwin's *On the Origin of Species*
Richard Dawkin's *The Selfish Gene*
Thomas Kuhn's *The Structure of Scientific Revolutions*
Geoffrey Parker's *Global Crisis: War, Climate Change and Catastrophe in the Seventeenth Century*
Mathis Wackernagel & William Rees's *Our Ecological Footprint*

## SOCIOLOGY

Michelle Alexander's *The New Jim Crow: Mass Incarceration in the Age of Colorblindness*
Gordon Allport's *The Nature of Prejudice*
Albert Bandura's *Aggression: A Social Learning Analysis*
Hanna Batatu's *The Old Social Classes And The Revolutionary Movements Of Iraq*
Ha-Joon Chang's *Kicking Away the Ladder*
W. E. B. Du Bois's *The Souls of Black Folk*
Émile Durkheim's *On Suicide*
Frantz Fanon's *Black Skin, White Masks*
Frantz Fanon's *The Wretched of the Earth*
Eric Foner's *Reconstruction: America's Unfinished Revolution, 1863-1877*
Eugene Genovese's *Roll, Jordan, Roll: The World the Slaves Made*
Jack Goldstone's *Revolution and Rebellion in the Early Modern World*
Antonio Gramsci's *The Prison Notebooks*
Richard Herrnstein & Charles A Murray's *The Bell Curve: Intelligence and Class Structure in American Life*
Eric Hoffer's *The True Believer: Thoughts on the Nature of Mass Movements*
Jane Jacobs's *The Death and Life of Great American Cities*
Robert Lucas's *Why Doesn't Capital Flow from Rich to Poor Countries?*
Jay Macleod's *Ain't No Makin' It: Aspirations and Attainment in a Low Income Neighborhood*
Elaine May's *Homeward Bound: American Families in the Cold War Era*
Douglas McGregor's *The Human Side of Enterprise*
C. Wright Mills's *The Sociological Imagination*

Thomas Piketty's *Capital in the Twenty-First Century*
Robert D. Putman's *Bowling Alone*
David Riesman's *The Lonely Crowd: A Study of the Changing American Character*
Edward Said's *Orientalism*
Joan Wallach Scott's *Gender and the Politics of History*
Theda Skocpol's *States and Social Revolutions*
Max Weber's *The Protestant Ethic and the Spirit of Capitalism*

## THEOLOGY

Augustine's *Confessions*
Benedict's *Rule of St Benedict*
Gustavo Gutiérrez's *A Theology of Liberation*
Carole Hillenbrand's *The Crusades: Islamic Perspectives*
David Hume's *Dialogues Concerning Natural Religion*
Immanuel Kant's *Religion within the Boundaries of Mere Reason*
Ernst Kantorowicz's *The King's Two Bodies: A Study in Medieval Political Theology*
Søren Kierkegaard's *The Sickness Unto Death*
C. S. Lewis's *The Abolition of Man*
Saba Mahmood's *The Politics of Piety: The Islamic Revival and the Feminist Subjec*t
Baruch Spinoza's *Ethics*
Keith Thomas's *Religion and the Decline of Magic*

## COMING SOON

Chris Argyris's *The Individual and the Organisation*
Seyla Benhabib's *The Rights of Others*
Walter Benjamin's *The Work Of Art in the Age of Mechanical Reproduction*
John Berger's *Ways of Seeing*
Pierre Bourdieu's *Outline of a Theory of Practice*
Mary Douglas's *Purity and Danger*
Roland Dworkin's *Taking Rights Seriously*
James G. March's *Exploration and Exploitation in Organisational Learning*
Ikujiro Nonaka's *A Dynamic Theory of Organizational Knowledge Creation*
Griselda Pollock's *Vision and Difference*
Amartya Sen's *Inequality Re-Examined*
Susan Sontag's *On Photography*
Yasser Tabbaa's *The Transformation of Islamic Art*
Ludwig von Mises's *Theory of Money and Credit*

Printed in the United States
by Baker & Taylor Publisher Services